Music Theory for Singers

Level Seven

Second Edition

Sarah Sandvig

Kendall Hunt
publishing company

Kendall Hunt
publishing company

www.kendallhunt.com
Send all inquiries to:
4050 Westmark Drive
Dubuque, IA 52004-1840

FOREWORD

In Sarah Sandvig's *Music Theory for Singers*, voice students and their teachers finally have a singer-friendly primer for musicianship and music theory that is directly applicable to voice training. Mrs. Sandvig has capitalized on her experience as a successful private voice teacher to create this comprehensive workbook, which, in clear, concise language, lays out an easy-to-follow lesson plan progressing from basic through advanced skills. *Music Theory for Singers* is equally applicable in a college or high school classroom setting as in the private studio, and voice teachers will especially appreciate the inclusion of international musical terminology, and music history which their students are likely to encounter in vocal repertoire. For teens studying voice for the first time, as well as for life-long adult singers, *Music Theory for Singers* will become a valued adjunct to any level of vocal study.

Juliana Gondek
Metropolitan Opera soloist and
Prize-winning international recording artist
Professor and Chair, Division of Voice Studies
UCLA

I am beginning my first semester as a BFA Musical Theatre Major at The Boston Conservatory at Berklee. I used Sarah's theory books throughout high school from levels 5 through 10, and they have prepared me immensely for this first semester – and beyond. For example, I recently went through a music theory and sight singing placement test: I was so amazed how comfortable I felt with both the written and singing portions. It was everything I had already learned from these theory books – key signatures, scales, rhythm, solfege, and more. In addition, I became so familiar with the fundamentals of music and a piano keyboard (even through utilizing the vocal theory books) I was able to test out of a whole year of beginner piano. All of this creates the possibility for me to move on to higher levels and be more challenged than if I had to start from the basics. Not to mention all of the composers and terms that are necessary knowledge to be successful in professional music classes and settings. It feels good to know that if I am ever unsure about what I am learning in class, my theory books are right there on the bookshelf to help me out.

Sofia Ross
Musical Theatre Major
Boston Conservatory

Thank you to the following people for their help and guidance in writing these books: Mary Beard, Melissa Caldretti, Sally Curry, Sharlae Jenkins, Vanessa Parvin, Connie Venti & my dad, Ken Watson.

Thank you to my husband Darren and sons Aiden & Caleb for their love, support and patience throughout this writing process.

NOTE TO TEACHER:
These books are a supplement to private, group or classroom voice lessons, and though I feel they can stand alone, they are not meant as a replacement for a good teacher who ensures student learning and understanding of music theory, history, and sight-singing. Each book includes reviews of subjects with a review test (with answers) at the end. You may also purchase the Answer Key, which has answers to all pages in each level, 1-10. Composers, terms, IPA and solfege are unique elements of these books that make them especially helpful for singers.

I hope these books are a useful addition to the many tools you already utilize to teach young singers in your studio or classroom.

TABLE OF CONTENTS

MUSIC THEORY FOR SINGERS
LEVEL 7

Review of Concepts in Level 6

Notes, Rhythm & Time Signature: Review

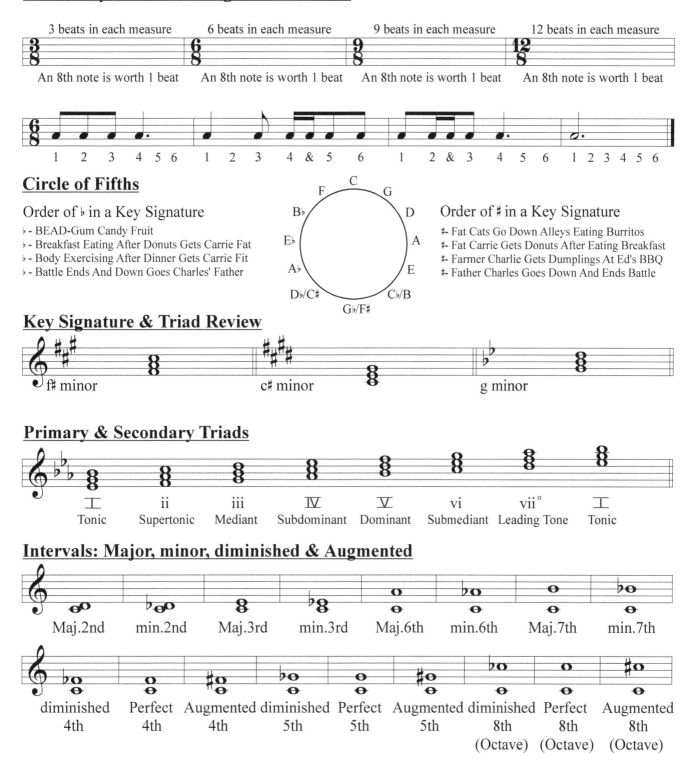

Circle of Fifths

Order of ♭ in a Key Signature

♭ - BEAD-Gum Candy Fruit
♭ - Breakfast Eating After Donuts Gets Carrie Fat
♭ - Body Exercising After Dinner Gets Carrie Fit
♭ - Battle Ends And Down Goes Charles' Father

Order of ♯ in a Key Signature

♯ - Fat Cats Go Down Alleys Eating Burritos
♯ - Fat Carrie Gets Donuts After Eating Breakfast
♯ - Farmer Charlie Gets Dumplings At Ed's BBQ
♯ - Father Charles Goes Down And Ends Battle

Key Signature & Triad Review

Primary & Secondary Triads

Intervals: Major, minor, diminished & Augmented

Triads: Major, minor, diminished & Augmented

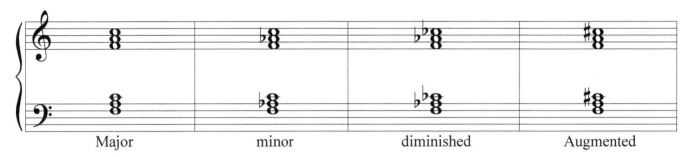

| Major | minor | diminished | Augmented |

Triads and Inversions

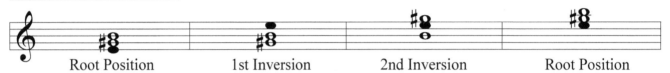

| Root Position | 1st Inversion | 2nd Inversion | Root Position |

IPA/Diction Review

ç	hue	[çju]	High tongue Middle touching hard palate sides touching top teeth Lips relaxed
x	loch (but don't let tongue touch the roof of your mouth)	[lɑx]	High tongue back arched towards soft palate with air Lips open, slightly rounded
ts	bats	[bæts]	Low tongue Tip between front teeth Lips relaxed
aʊ (diphthong: 2 vowel sounds)	shout	[ʃaʊt]	Low tongue then high tongue tip behind bottom teeth then sides touching top teeth Lips tall then rounded

Sight-Singing Review

Rhythm

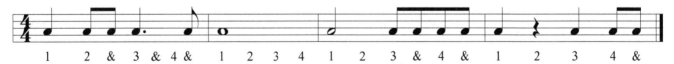

Melodic (with Solfege)

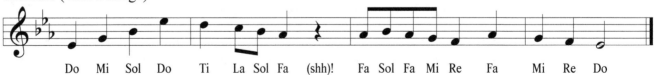

Do Mi Sol Do Ti La Sol Fa (shh)! Fa Sol Fa Mi Re Fa Mi Re Do

Lesson 1: The Chromatic Scale

A <u>Chromatic Scale</u> is comprised entirely of half steps.
An <u>ascending</u> Chromatic scale beginning on C is: C, C#, D, D#, E, F, F#, G, G#, A, A#, B, C.
A <u>descending</u> Chromatic scale beginning on C is: C, B, Bb, A, Ab, G, Gb, F, E, Eb, D, Db, C.

Chromatic Scale on the Grand Staff

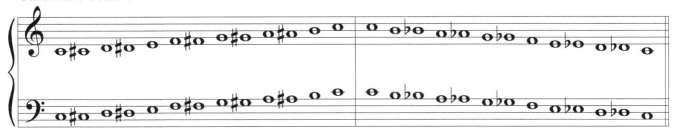

Look at the notes on a piano as well to see the half steps.

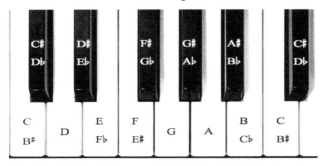

Below is the solfege for a chromatic scale beginning on C.

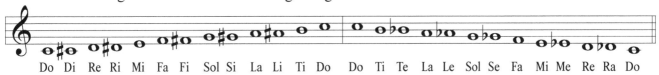

Notice how naturals and double flats are necessary to create the Db chromatic scale below.

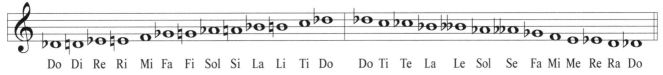

Here are some more examples of chromatic scales beginning on various pitches.

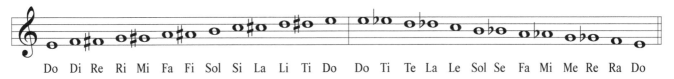

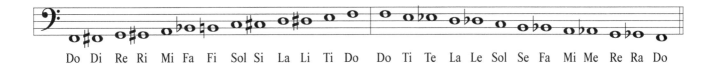

Review: Lesson 1

1. Draw <u>ascending</u> chromatic scales on each of the staves below.
 -Notice that each "system" (Grand Staff) starts on a different note. Be careful of the natural half steps (between E-F and B-C).
 -Use whole notes & refer to the keyboard below if you need help.

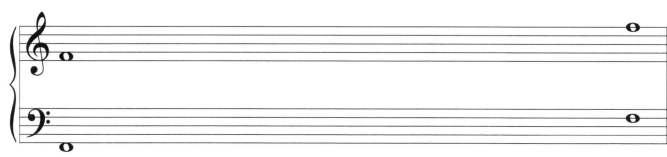

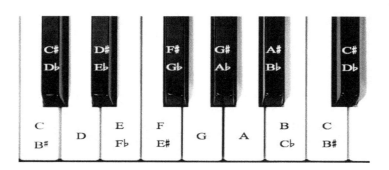

MUSIC THEORY FOR SINGERS

2. Draw <u>descending</u> chromatic scales on each of the staves below.
 -Notice that each "system" (Grand Staff) starts on a different note. Be careful of the natural half steps
 (between E-F and B-C).
 -Use whole notes & refer to the keyboard below if you need help.

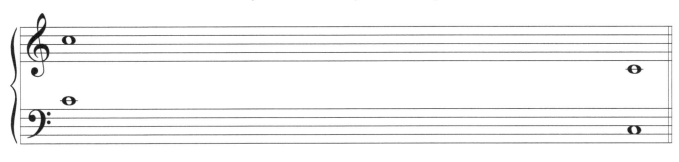

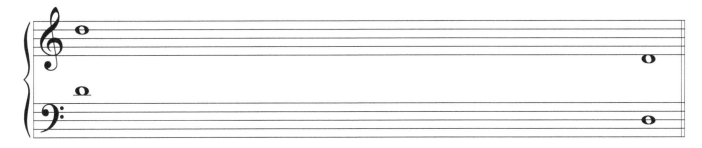

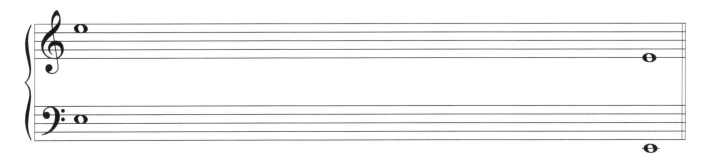

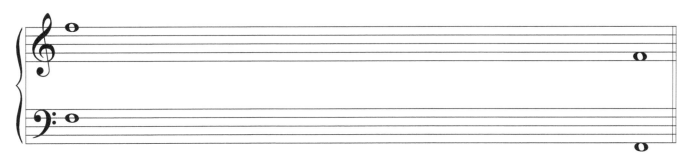

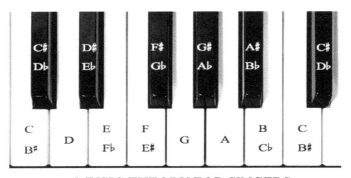

3. Add accidentals to complete the **ascending** chromatic scales below.

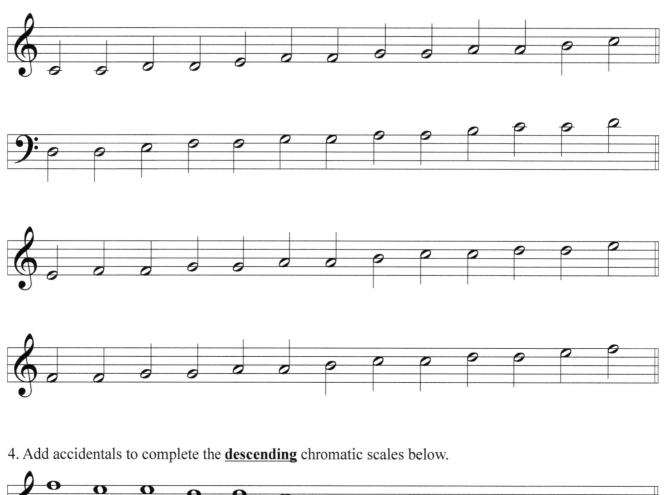

4. Add accidentals to complete the **descending** chromatic scales below.

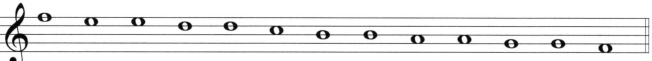

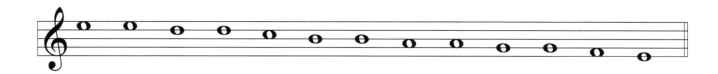

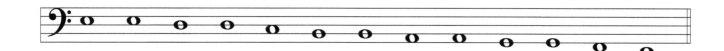

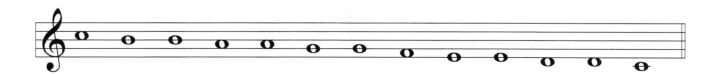

Lesson 2: Enharmonic Notes

An <u>Enharmonic Note</u> is the name for two notes that have the same pitch, but different names.

For example: F♯ & G♭ have the same pitch (sound the same), but have a different name, depending on what key the music is in.

Look at the keyboard below to see all of the enharmonic notes (notes with two names on them).

Here are the Enharmonic notes on the Grand Staff.

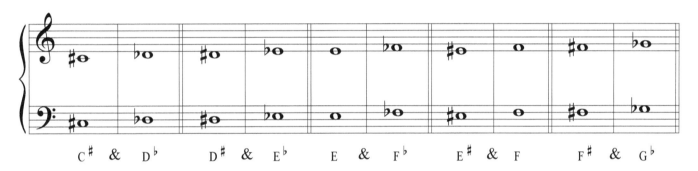

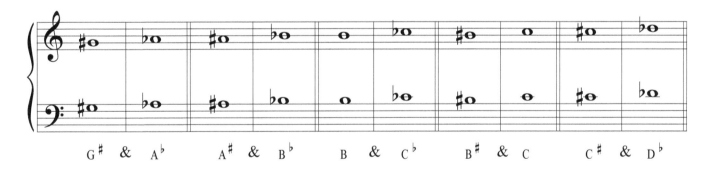

When songs are in keys with sharps (G, D, A, E, B, F♯, C♯), you will see enharmonic notes named as sharps. For example, an A♯ would not be called a B♭ in the key of B Major.

When songs are in keys with flats (F, B♭, E♭, A♭, D♭, G♭, C♭), you will see enharmonic notes named as flats. For example, a B♭ would not be called an A♯ in the key of B♭ Major.

In minor keys, you will sometimes see sharps or naturals added to notes, even if the key has flats in it. These added accidentals create different forms of minor keys which will be covered in Levels 8 & 9.

Review: Lesson 2

1. Name the enharmonic note for the given note. The first one is done for you.

C♯ & _Db_ F♯ &_____ E &_____ A♭ &_____ G♯ &_____ B♭ &_____

E♭ &_____ A♯ &_____ F♭ &_____ B♯ &_____ E♯ &_____ D♭ &_____

2. Fill in the missing enharmonic note names on the keyboards below. If you need help, you can refer to the keyboard on page 7.

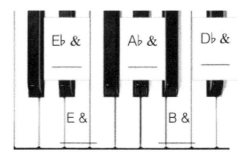

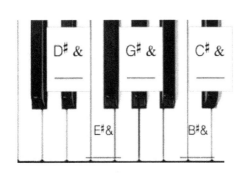

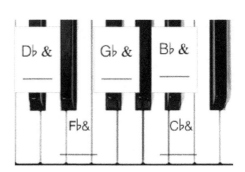

3. Name the following pairs of enharmonic notes.

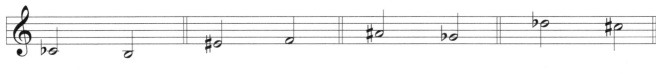

_____ & _____ _____ & _____ _____ & _____ _____ & _____

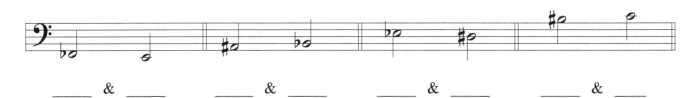

_____ & _____ _____ & _____ _____ & _____ _____ & _____

4. On the staves below, write the enharmonic note for each given note. The first one is done for you.

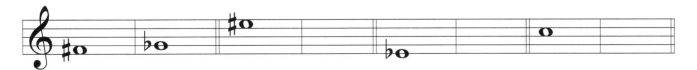

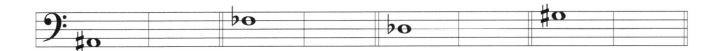

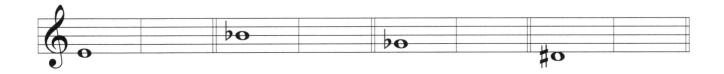

Lesson 3: Minor Key Signatures

In music, a Key Signature is a series of sharp (#) or flat (♭) symbols placed on the staff immediately after the Treble and Bass clef. The Key Signature also creates the tonal center (Do) for a piece. If a piece is in D Major, D is Do.

The key signature shows which notes are to be sung a half step higher (sharp) or a half step lower (flat) for the duration of the piece.

Every Major key has a "relative" minor key. The easiest way to understand the difference between the sound of songs in a Major and minor key is:

<div style="text-align:center">

Major key = Happy minor key = Sad

</div>

In order for a scale to be in a minor key, the notes must follow a specific pattern of half steps and whole steps.

The pattern of half steps and whole steps that make up a <u>minor</u> scale (8 notes) is as follows.

Whole - Half - Whole - Whole - Half - Whole - Whole (W - H - W - W - H - W - W)

Take a look at a c minor scale on the staff below. The E♭, A♭ & B♭ must be added in order for the formula (pattern of half steps and whole steps) to be correct.

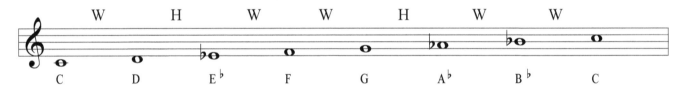

Here is what a c minor scale looks like on a piano keyboard.

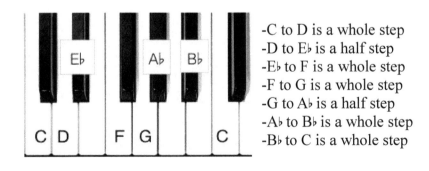

-C to D is a whole step
-D to E♭ is a half step
-E♭ to F is a whole step
-F to G is a whole step
-G to A♭ is a half step
-A♭ to B♭ is a whole step
-B♭ to C is a whole step

*Remember the "natural half steps" between B-C and E-F. These pitches are right next to each other. Look at the keyboard above to see how close they are on a piano!

Every Major key is related to a minor key because they share the same key signature (sharps/flats). For instance, E♭ and c minor are related because they both have a B♭, E♭ & A♭ in the key signature. If you sing a scale starting on E♭ (as Do) E♭ - F - G - A♭ - B♭ - C - D - E♭, it will sound happy (Major). If you sing the same scale starting on C (as Do or La) C - D - E♭ - F - G - A♭ - B♭ - C, it will sound sad (minor).

There are two ways to find a Major key's relative minor key.

1. The relative minor key (Do) is the 6th note of a Major key's scale. In solfege, this is the "La."

2. The relative minor key is a minor 3rd (3 half steps) lower than the Major Key's Do.

Look at the following example. C (La) is the 6th note of the E♭ Major Scale. It is the relative minor key.

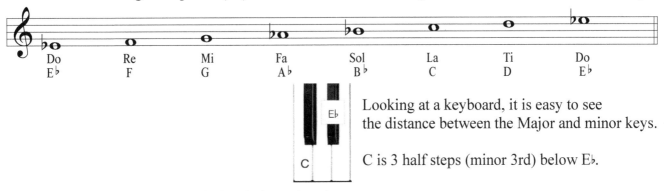

Do	Re	Mi	Fa	Sol	La	Ti	Do
E♭	F	G	A♭	B♭	C	D	E♭

Looking at a keyboard, it is easy to see the distance between the Major and minor keys.

C is 3 half steps (minor 3rd) below E♭.

Here are three Major keys and their relative minor keys.

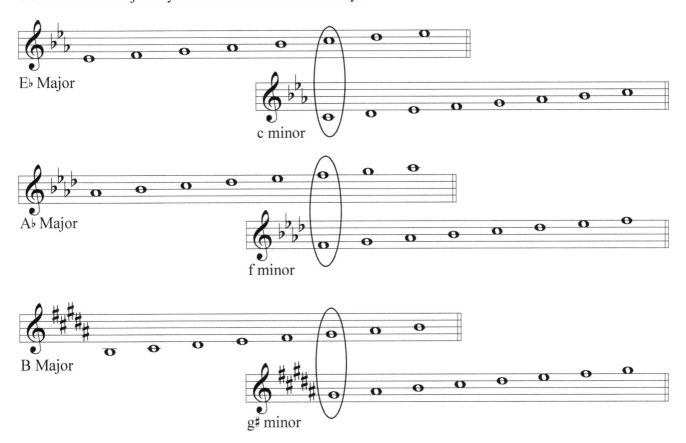

E♭ Major

c minor

A♭ Major

f minor

B Major

g♯ minor

Here are some familiar melodies in minor keys.

"Scarborough Fair" - English Folksong

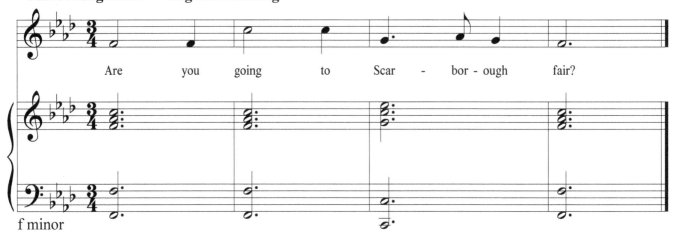

Are you going to Scar - bor - ough fair?

f minor

"God Rest ye Merry Gentlemen" - traditional Christmas Carol

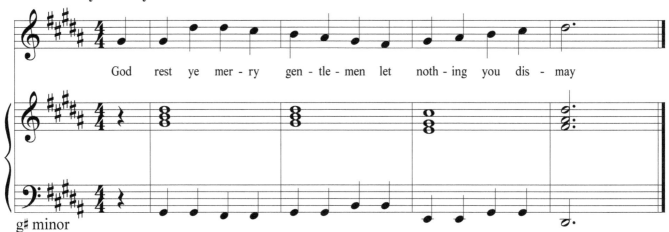

God rest ye mer - ry gen - tle - men let noth - ing you dis - may

g♯ minor

"Für Elise" - Beethoven

a minor

Review: Lesson 3

1. Circle the correct pattern of Whole steps and Half steps that create a minor scale.

 a. W W H W W W H

 b. W H W W H W W

2. Check the correct answer for the following:

 a. A relative minor key shares the same_____as the Major Key.

 b. You can find the relative minor key by looking at the_____of the Major scale.

 c. Songs in a minor key sound_____while Major keys sound_____.

3. Fill in the relative minor key for each of the Major keys listed. Refer to the piano to count down 3 half steps to find the minor key, or go to the La of the scale.

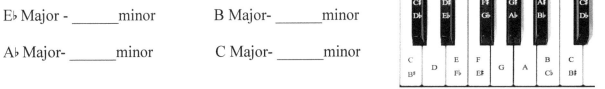

 E♭ Major - _____minor B Major- _____minor

 A♭ Major- _____minor C Major- _____minor

4. Circle the relative minor note (La) in each of these Major scales.

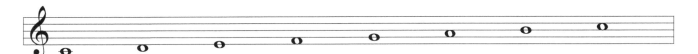

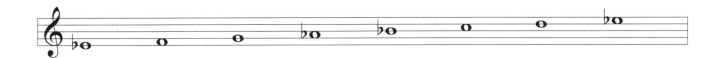

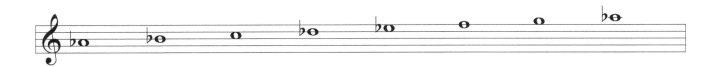

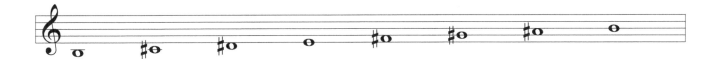

5. Add whole notes and accidentals to complete each scale. Draw **ascending** scales only.
Do not use a key signature.
It helps to think of the key signature for the relative Major key, then add the same ♯/♭ to the minor scale.
Use the keyboard below for help.

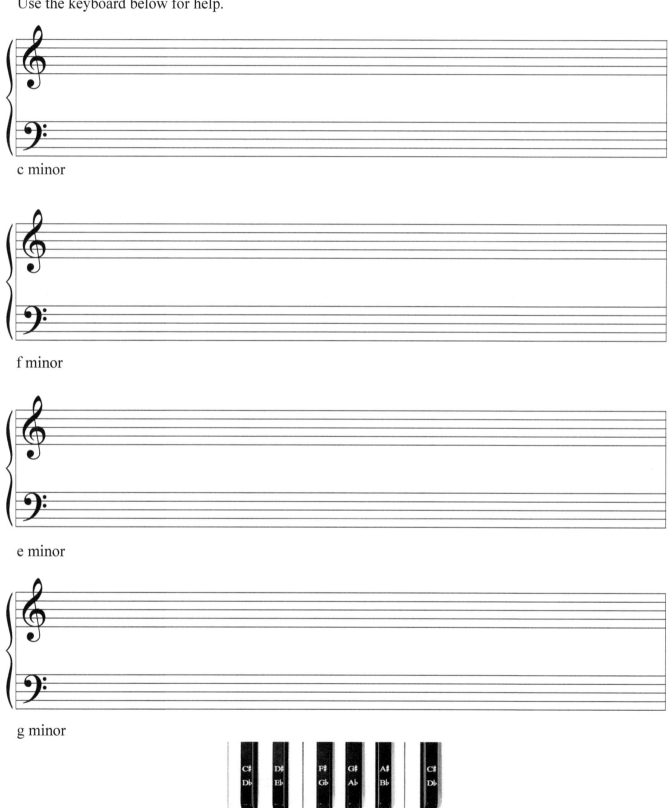

c minor

f minor

e minor

g minor

6. What is the order of sharps in a key signature? (look on page 1 for hints)

_____ _____ _____ _____ _____ _____ _____

7. What saying can be used to remember the order of sharps?

8. What is the order of flats in a key signature?

_____ _____ _____ _____ _____ _____ _____

9. What saying can be used to remember the order of flats?

10. The order of sharps is in the_____order than the order of flats.

11. Draw the sharps 2 times, in order, on both the treble and bass staves. Be careful that the center part of the sharp is on the correct line or space.

12. Draw the flats 2 times, in order, on both the treble and bass staves. Be careful that the center part of the flat is on the correct line or space.

13. Name the sharps, in order, in the following keys. The first one is done for you.

F♯, C♯ _____

14. Name the flats, in order, in the following keys. The first one is done for you.

B♭, E♭

15. For the following examples:
-Determine the key, and if it begins and ends in the Major or minor key.
-Write the note names underneath the notes. Be sure to add the ♯/♭ after the letter, if the note is affected by the key signature. Watch the clef changes - it may help to circle the Bass clefs so you don't forget! The first measure is done for you.

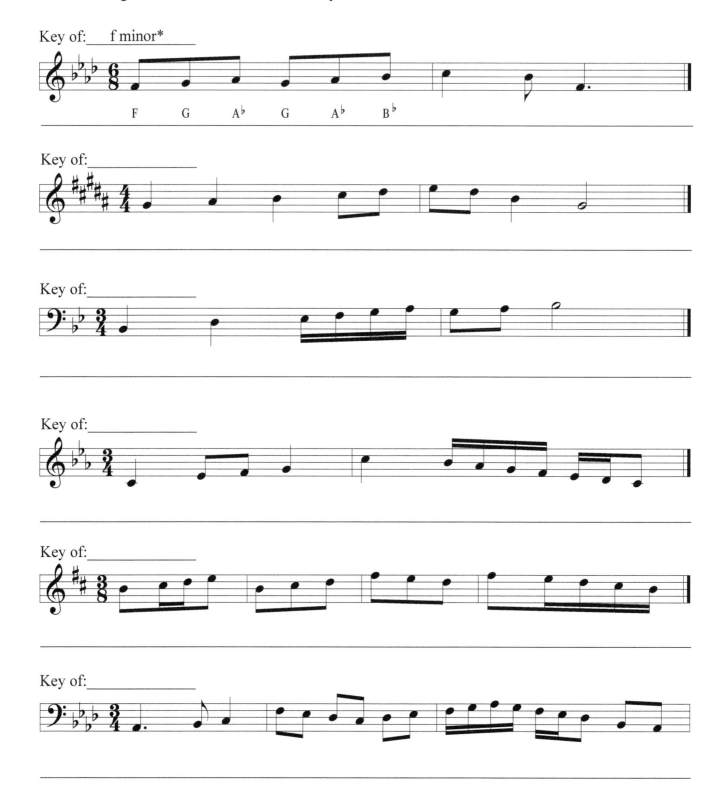

Key of:___f minor*___

F G A♭ G A♭ B♭

Key of:_____

Key of:_____

Key of:_____

Key of:_____

Key of:_____

*starts and ends on an F, so in this example, F is "Do (or La)."

16. Name the following **Major** key signatures. Don't forget to add a #/♭ next to the letter name, if necessary. The first one is done for you.

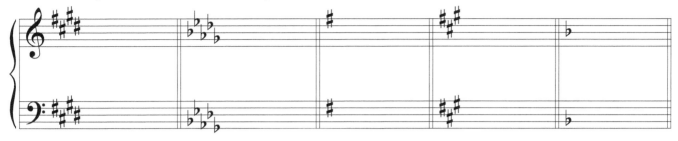

E Major

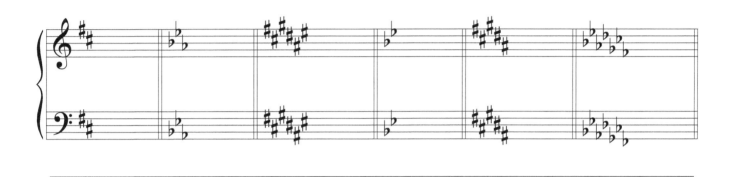

17. Name the following **minor** key signatures.

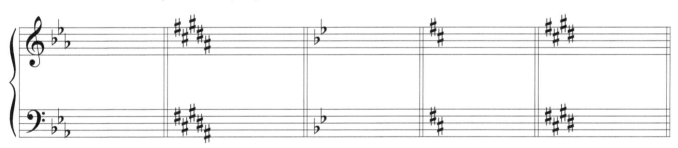

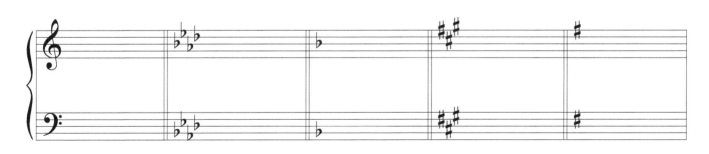

Lesson 4: Minor Triads

A **Triad**, or 3-note chord, is formed when the first, third and fifth notes of a scale are sung or played, either consecutively or at the same time. The root, or the lowest note of a triad, determines its letter name.

Example: c minor c is the 1st/root, e♭ is the 3rd/middle note, g is the 5th/top note

This is a "root position" chord.

The following example show minor scales and how minor triads are formed by starting on the first note of the scale (Do). The 1st, 3rd, and 5th notes (Do-Mi-Sol) are circled.

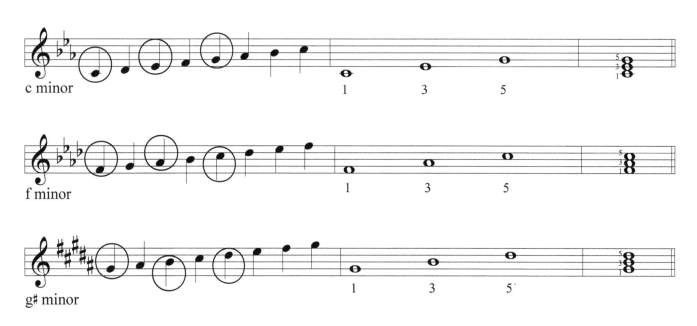

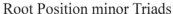
Root Position minor Triads

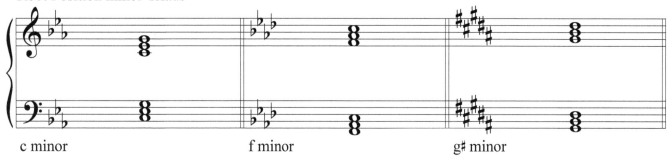

c minor f minor g♯ minor

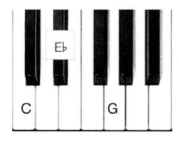

This is what a c minor triad looks like on a piano keyboard.

Review: Lesson 4

1. Name the following minor triads. Remember, look at the bottom note (root) for the "name" of the triad.

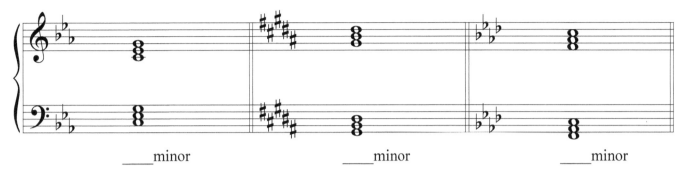

 ____minor ____minor ____minor

2. The following triads are in the relative Major keys to above minor triads. Name each Major triad.

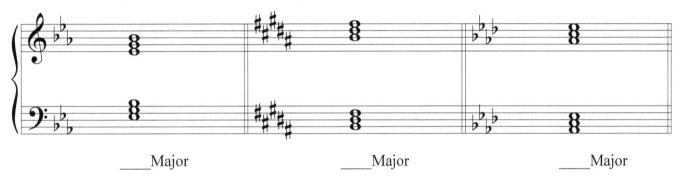

 ____Major ____Major ____Major

3. For the following examples, <u>draw the correct key signature</u>, then <u>add the root position triads</u> to both the Treble and Bass clefs. Look at questions 1 & 2 for hints.

 B Major E♭ Major A♭ Major

 f minor g♯ minor c minor

4. Circle the three notes in the minor scales below that make up a root position triad.

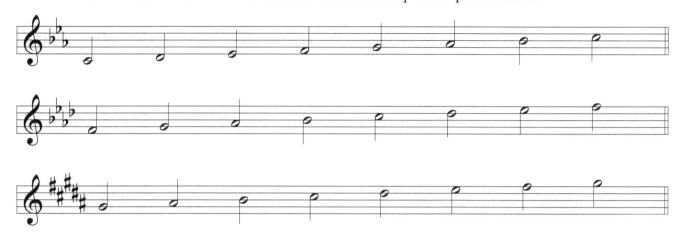

5. Each of these Major and minor triads should have 3 notes (Do-Mi-Sol/root-middle-top).
 <u>Fill in the missing note</u> to create a root position triad for the given key.

Major keys

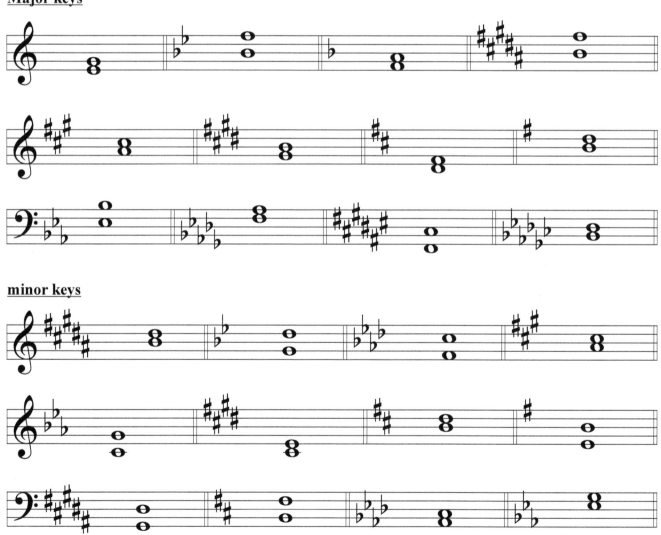

minor keys

Review: Lessons 1-4

1. Add accidentals to complete the **ascending** chromatic scale beginning on C.

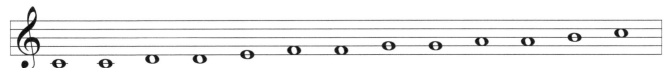

2. Add accidentals to complete the **descending** chromatic scale beginning on C.

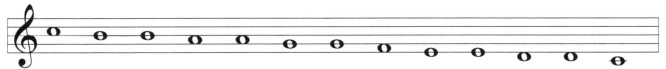

3. On the staves below, write the enharmonic note for each given note.

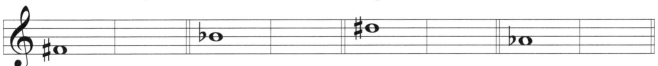

4. Name the Major key for each key signature.

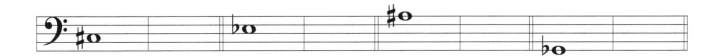

_____Major _____Major _____Major _____Major _____Major _____Major

5. Name the minor key for each key signature.

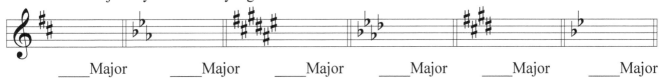

_____minor _____minor _____minor _____minor _____minor _____minor

6. Draw the correct key signature, then add the root position triads for each **minor** key.

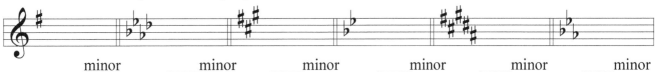

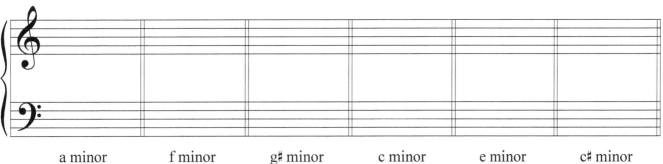

a minor f minor g# minor c minor e minor c# minor

7. Fill in the missing note to create a root position triad for the given **minor** keys.

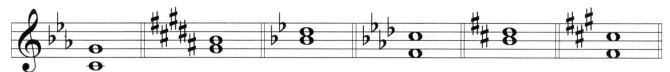

8. Add whole notes and accidentals to complete each scale. Draw **descending** scales only.
 Do not use a key signature.

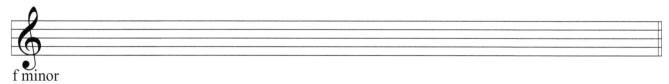

f minor

g♯ minor

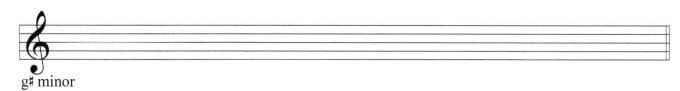

c minor

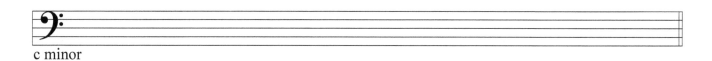

B Major

F Major

D Major

e minor

Lesson 5: Ornaments: Musical Embellishments

Musical embellishments called "ornaments" are added to the vocal line to decorate or "ornament" that line.

They are not the main melody notes, and often delay the melody notes, so that when you do hear the main notes they are even more satisfying.

In the Baroque period, singers would improvise ornaments in most pieces, and especially in da capo arias. When the singer would sing the A section the second time, they would add several ornaments so it wasn't an exact repeat of the opening.

Ornaments can be found in all forms of classical music and even music from today. In pop, Jazz, and some Musical Theater music, singers often "riff" or add "runs" to the melody lines of the song. These are modern day ornaments!

Some composers write in the specific ornaments they want the singers to sing. While there are several ornaments, three of the most common ornaments found in Classical music are the Appoggiatura, Mordent & Grace Note.

The Appoggiatura: This is an accented, non-harmonic note that resolves stepwise to a harmonic note, often written in small type.

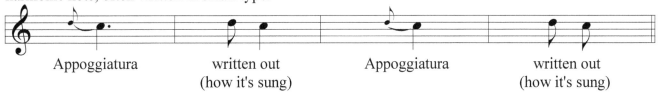

Appoggiatura written out Appoggiatura written out
 (how it's sung) (how it's sung)

(The Appoggiatura always gets its full value, and this value is subtracted from the note of resolution).

The Mordent: This is an ornament where the main note and the note below are sung quickly in succession before returning to the main note.

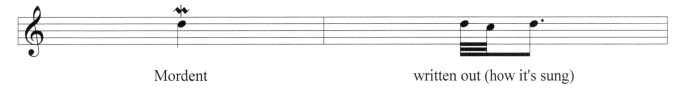

Mordent written out (how it's sung)

The Grace Note: This is an unaccented ornament consisting of a short note immediately before a longer-lasting note. Grace notes are written in small type, with a slash through the stem.

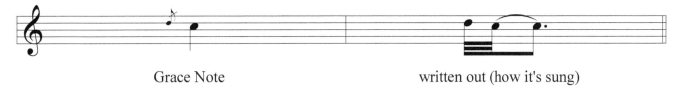

Grace Note written out (how it's sung)

Here are some examples of each ornament within a piece of music.

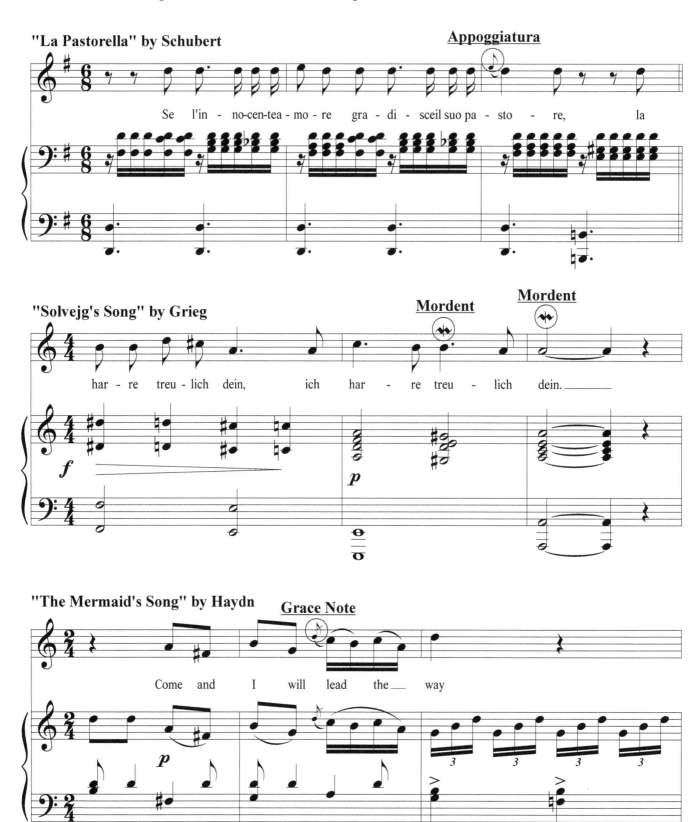

Review: Lesson 5

Answer the following questions about ornaments.

1. Ornaments are only included in music from the Baroque period. (Circle True or False)

<div align="center">

True False

</div>

2. Ornaments are part of the main melody in music. (Circle True or False)

<div align="center">

True False

</div>

3. Singers often add ornaments to what type of song? (Circle your answer)

<div align="center">

Folk Songs Da capo Arias

</div>

4. Draw a line connecting the ornament on the left to its correct written out version on the right.

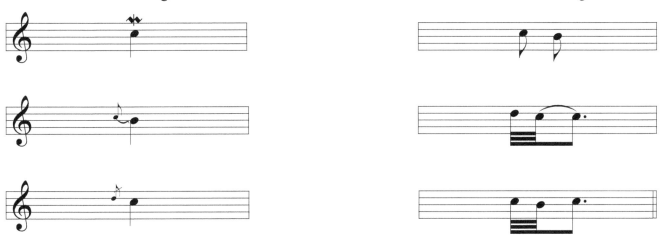

5. Write the name under each ornament in the following musical example:
 Appoggiatura, Mordent & Grace Note.

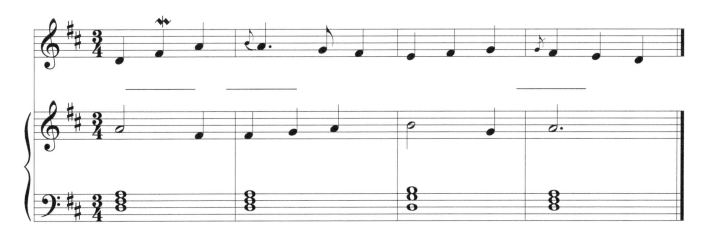

Lesson 6: Rhythm Review

A <u>Time Signature</u> tells us how many beats are in each measure of music, (top number)
and what type of note gets one beat (bottom number).

Remember, if a 4 is on the bottom, a quarter note receives one beat, and eighth note receives half a beat,
a half note receives 2 beats, etc. If an 8 is on the bottom, and 8th note receives one beat, a quarter note
receives 2 beats, a half note receives 4 beats, etc.

An easy way to think about note & rest values in time signatures with an 8 on the bottom is: All notes
are worth twice as much as they are in common time (4/4) and any other time signature with a 4 on the
bottom.

Below is a review of rhythms in various time signatures. The beats have been written under
the notes/rests as well as "La" to show you how to sing these rhythms.

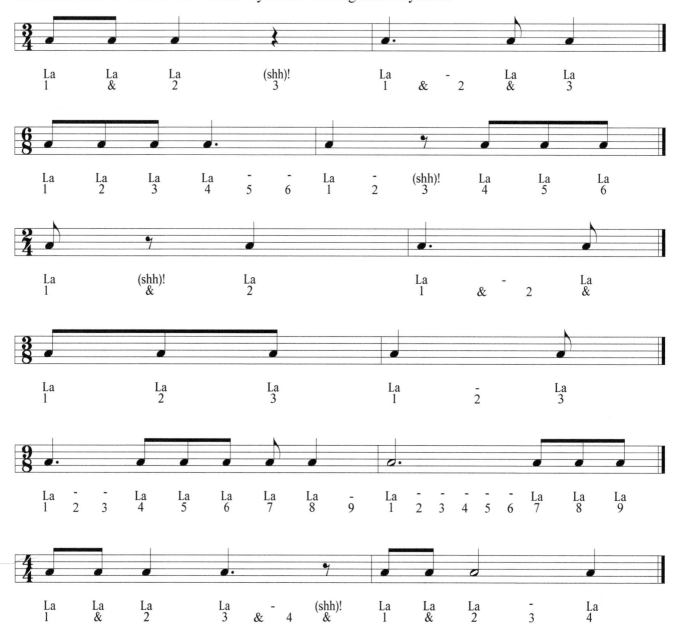

Review: Lesson 6

1. Check the correct counting for the following examples.

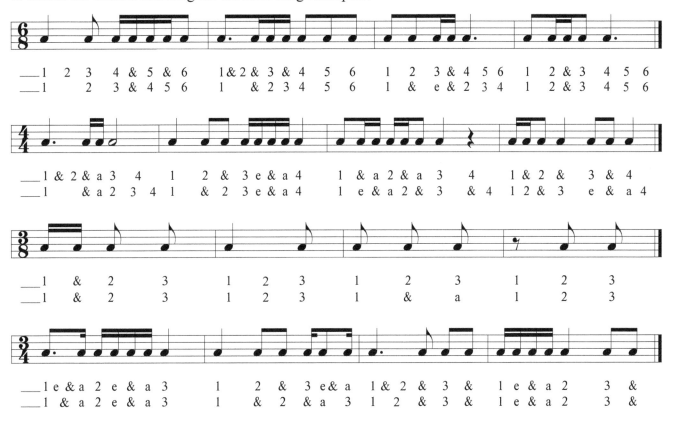

2. Add one missing note or rest to each measure.

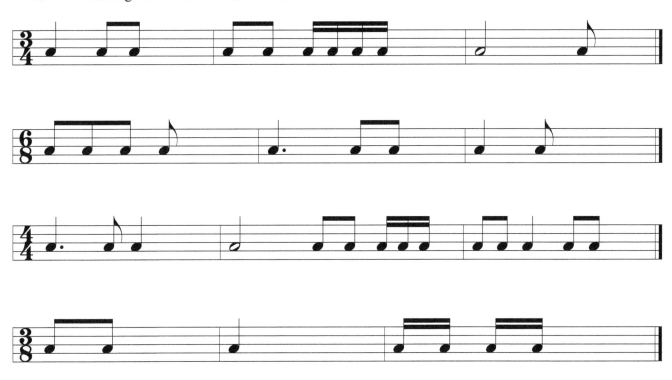

3. For the following examples:
 -Write the beats underneath the notes/rests in each example.
 -Add the three missing bar lines
 -Add a double bar line.

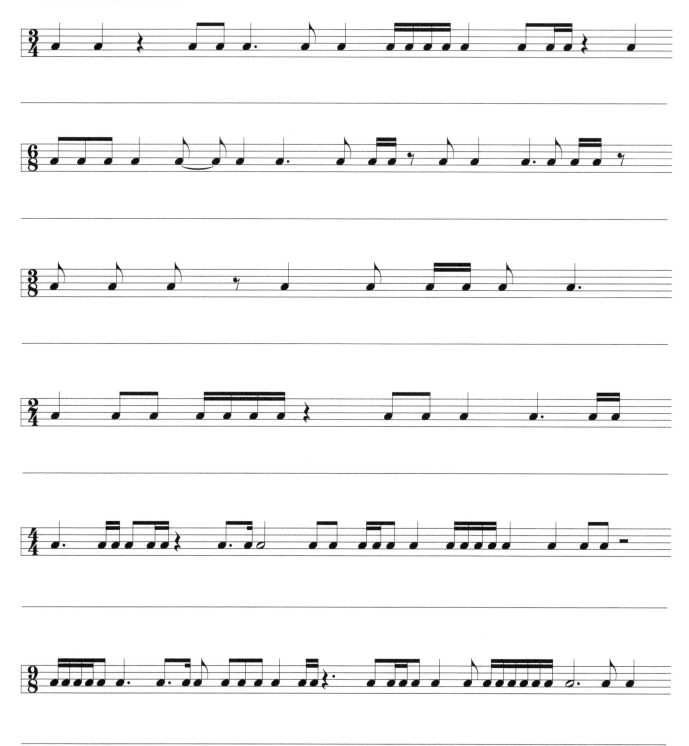

4. Mark the correct time signature below for the following examples.

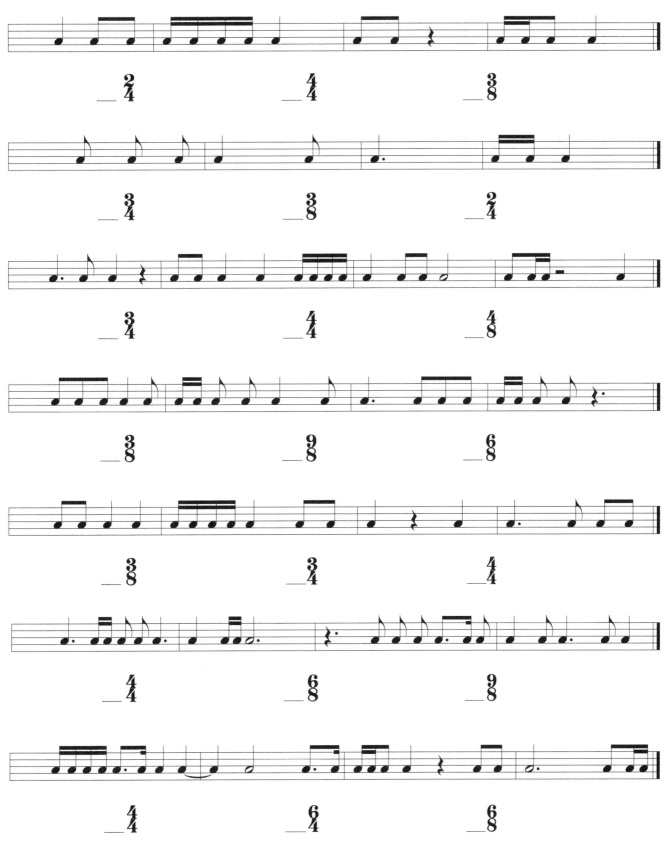

Lesson 7: Chord Progressions

A <u>Chord Progression</u> is a series of chords that helps to establish tonality within a song. For singers, chord progressions can usually be found in the piano accompaniment, or in the vocal line within a choral piece. In this lesson, you will learn about the most commonly found chord progression:

$$\text{I} - \text{IV} - \text{V} - \text{I} \quad \text{(Major)}$$

$$\text{i} - \text{iv} - \text{V} - \text{i} \quad \text{(minor)}$$

Major Keys:

The Tonic chord (I) consists of the Root, 3rd and 5th notes of the Major Scale, and is a Major triad.

The Subdominant chord (IV) is a Major triad built on the 4th note of the Major Scale.

The Dominant chord (V) is a Major triad built on the 5th note of the Major Scale.

Look at the example below in C Major.

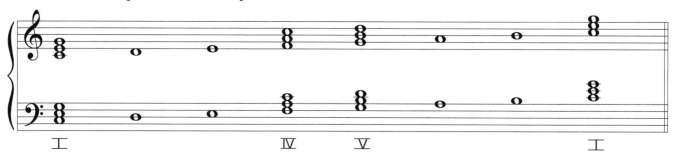

minor Keys: *Notice how the Tonic and Subdominant use lower case Roman numerals to indicate minor chords.*

The Tonic chord (i) consists of the Root, 3rd and 5th notes of the minor Scale, and is a minor triad.

The Subdominant chord (iv) is a minor triad built on the 4th note of the minor Scale.

The Dominant chord (V) is a Major* triad built on the 5th note of the Major Scale.

Look at the example below in a minor.

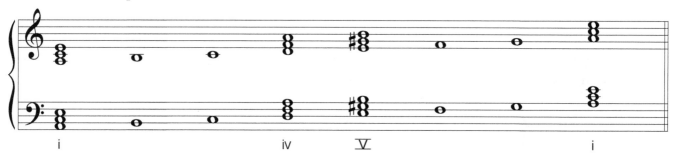

*In minor chord progressions, the Dominant chord (V) is typically a Major chord with a raised 3rd. This will be covered in more depth in Level 8.

Chord progressions are often found in 1st and 2nd inversions. In level 6, you learned that an inversion of a chord is simply rearranging the notes in a different order, like juggling. The three notes in the triad do not change, just their order does.

Typically, the Ⅳ chord is found in 2nd inversion, while the Ⅴ chord is found in 1st inversion. The Ⅰ chord is usually found in Root Position.

Keep in mind that chords can be in any inversion; the order of the notes doesn't matter, just the notes themselves.

Below is a musical example with chord progressions in the accompaniment.

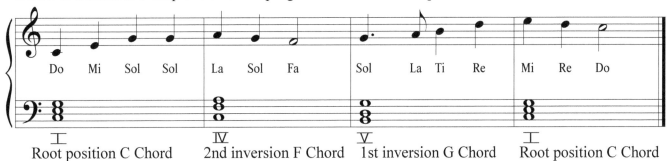

Here are some chord progressions in additional keys, demonstrating both Root positions and inversions.

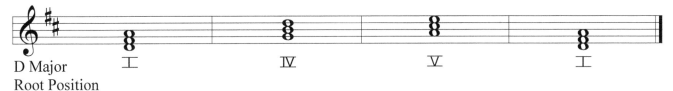

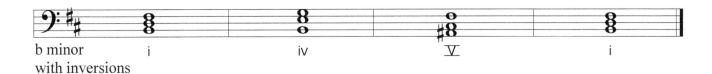

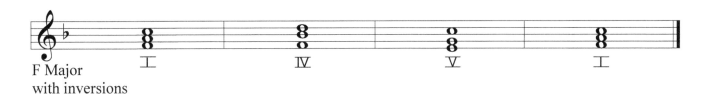

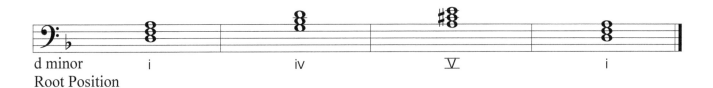

Review: Lesson 7

1. Label the following chord progressions with correct Roman Numerals. Remember to use lower case Roman Numerals for minor chords.

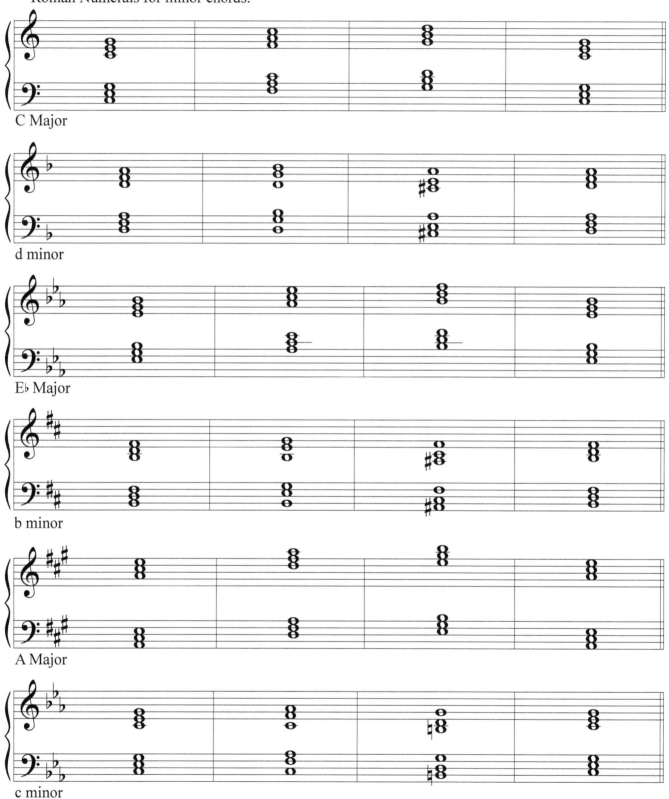

C Major

d minor

E♭ Major

b minor

A Major

c minor

2. Write the requested primary chords in both clefs for the following chord progression. Use root position chords. Don't forget to raise the middle note of the V chord if the example is in a minor key. This means you may need to add a sharp or natural sign.

F Major I IV V I

g minor i iv V i

B Major I IV V I

e minor i iv V i

A♭ Major I IV V I

b♭ minor i iv V i

Lesson 8: Cadences

In music, a cadence is a progression of at least two chords that ends a phrase, section, or piece of music. The most common cadences are the **Authentic**, **Plagal** and **Half** Cadences.

<u>Authentic Cadence:</u> Ⅴ - Ⅰ

<u>Plagal Cadence:</u> Ⅳ - Ⅰ

<u>Half Cadence:</u> Ⅰ - Ⅴ or Ⅳ - Ⅴ

When a phrase, section or piece of music ends on the Tonic chord (Ⅰ), it sounds final, or complete. A Half Cadence ends on the Ⅴ , so it sounds incomplete. One way to remember the Half Cadence is that it's "Half-done" or "Half-over."

Below are examples of Authentic, Plagal and Half Cadences in the key of F Major. You will see examples of the cadences in Root position.

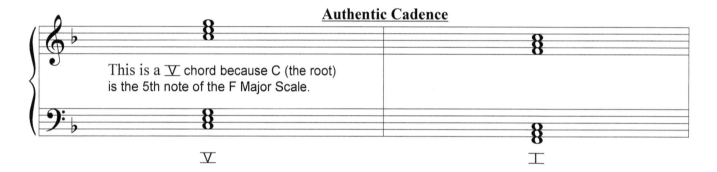

Authentic Cadence

This is a Ⅴ chord because C (the root) is the 5th note of the F Major Scale.

Ⅴ Ⅰ

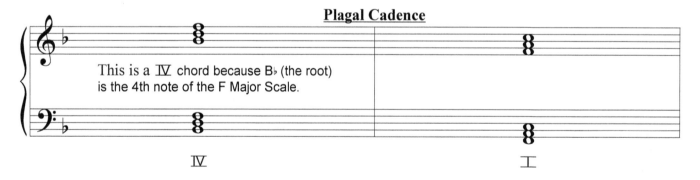

Plagal Cadence

This is a Ⅳ chord because B♭ (the root) is the 4th note of the F Major Scale.

Ⅳ Ⅰ

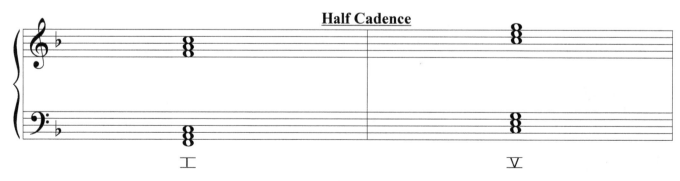

Half Cadence

Ⅰ Ⅴ

This musical example has Major chord progressions and an Authentic Cadence.

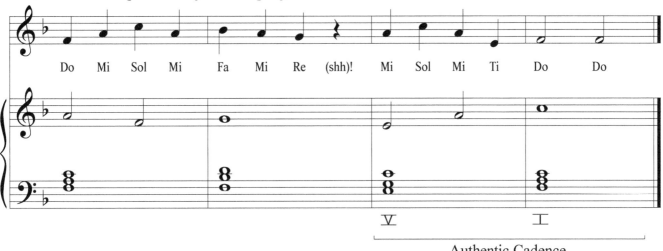

This musical example has minor chord progressions and a Plagal Cadence.

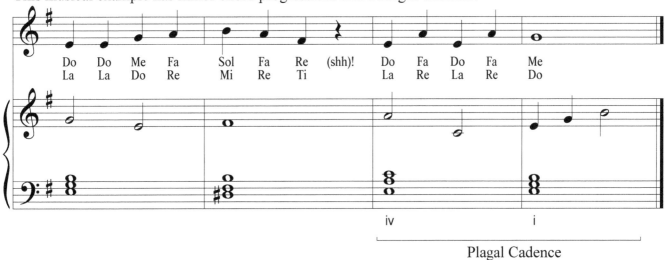

This musical example has Major chord progressions and a Half Cadence.

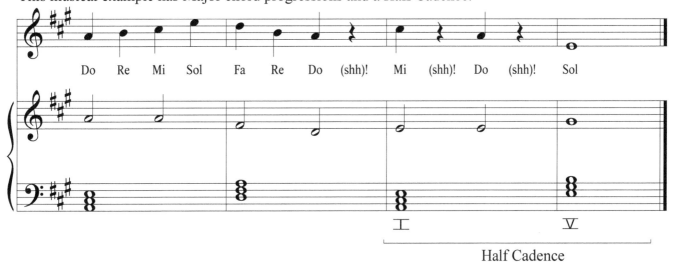

Review: Lesson 8

1. Write the correct Roman Numerals under the chords then label each cadence as "Authentic," "Plagal," or "Half." Remember, the I chord is whatever key you are in. Look at the bottom note to find the root of each chord (all chords are in root position). You can write the name of the bottom note of each triad, or color it in to help you identify it. The first one is done for you.

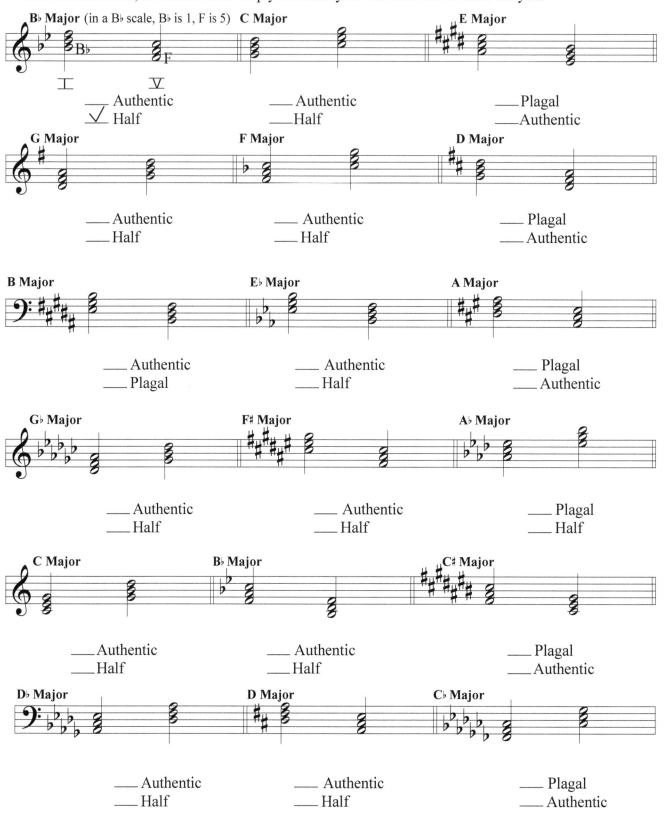

2. Look at the following musical examples and label the cadence (Authentic, Plagal or Half) in the last two measures.

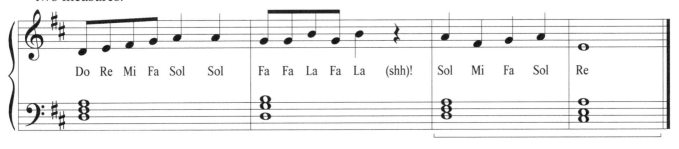

_____Cadence

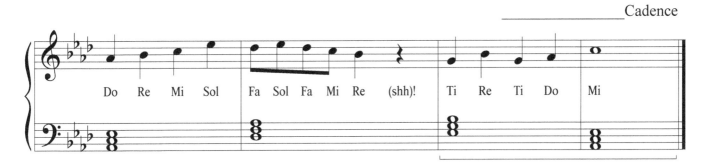

_____Cadence

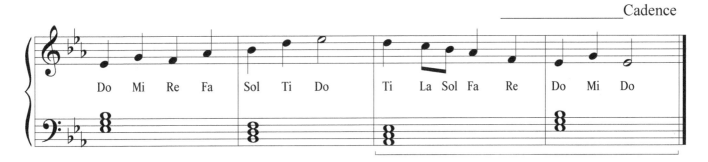

_____Cadence

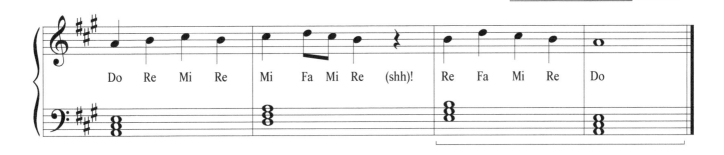

_____Cadence

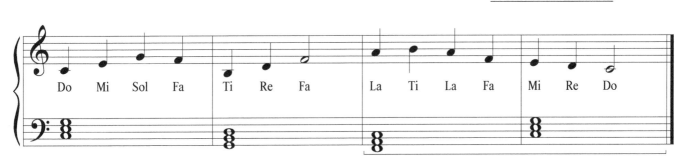

_____Cadence

Review: Lessons 5-8

1. Draw a line connecting the ornament on the left to its correct written out version.

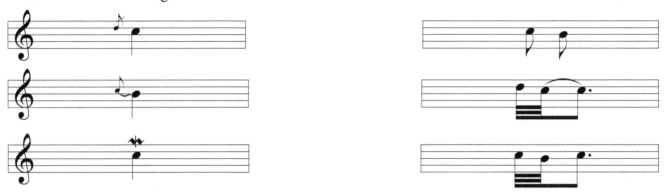

2. Choose the correct name for the following ornaments.

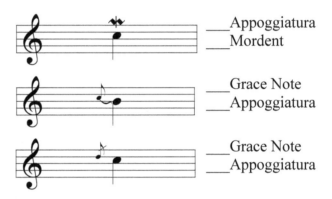

___Appoggiatura
___Mordent

___Grace Note
___Appoggiatura

___Grace Note
___Appoggiatura

3. Check the correct counting for the following example.

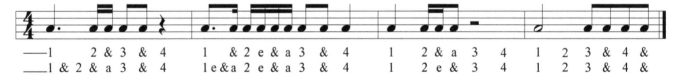

```
——1      2 & 3 & 4        1  & 2 e & a 3 &  4        1    2 & a  3    4      1   2   3 & 4 &
——1 & 2  & a 3  &  4      1 e & a 2 e & a 3  &  4     1    2 e & 3    4      1   2   3 & 4 &
```

4. Add one missing note or rest to each measure.

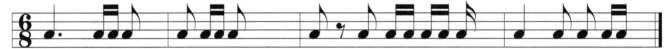

5. Mark the correct time signature below for the following example.

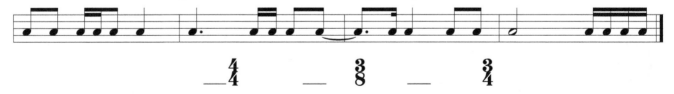

__ $\frac{4}{4}$ __ $\frac{3}{8}$ __ $\frac{3}{4}$

6. Add three bar-lines and a double bar line to this rhythm.

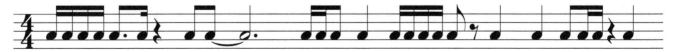

7. Write the requested primary chords in both clefs for the following chord progression. Use root position chords. Don't forget to raise the middle note of the V chord if the example is in a minor key.

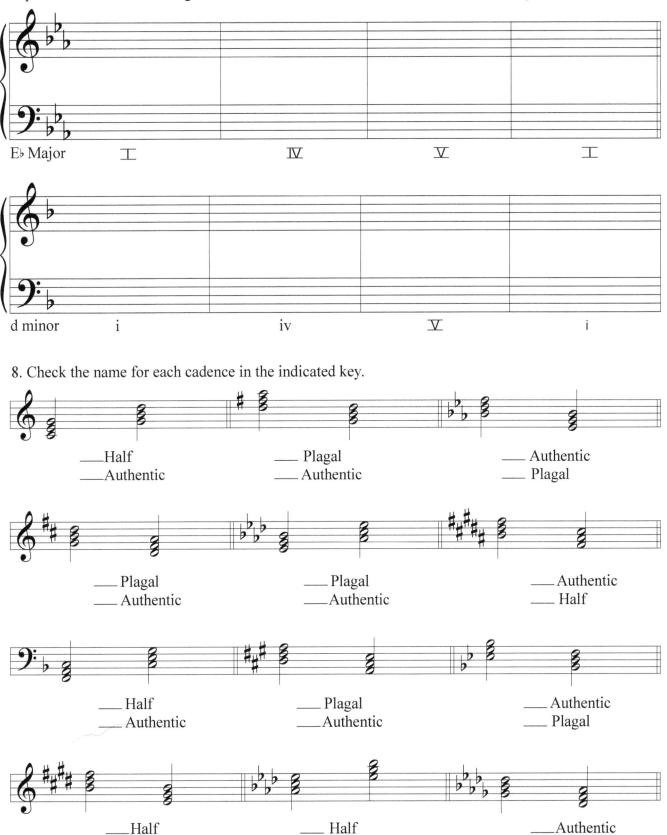

8. Check the name for each cadence in the indicated key.

____Half ____ Plagal ____ Authentic
____Authentic ____ Authentic ____ Plagal

____ Plagal ____ Plagal ____ Authentic
____ Authentic ____ Authentic ____ Half

____ Half ____ Plagal ____ Authentic
____ Authentic ____ Authentic ____ Plagal

____Half ____ Half ____ Authentic
____Authentic ____ Authentic ____ Plagal

Lesson 9: Voice Classifications

It's important for you, as a singer, to understand your voice type. Voice type depends on many factors including the length and width of your vocal cords (longer & thicker cords produce lower sounds, children have shorter cords than adults, thinner cords produce higher sounds...) Voice types also change over time, especially during adolescence.

One of the only ways for you to know what your cords look like is to have a scope done by an ENT (Ear, Nose & Throat Doctor). With a strobe light attached to the end of a wire, the doctor will be able to view your cords (either up a nostril, or down your throat). This is especially important if you have any issues with your voice, such as hoarseness, a fuzzy sound, or it feels different than usual when you sing. While having a scope done can be slightly uncomfortable, it is not painful, and well worth it!

You want to sing in a comfortable range (also called your tessitura). Your range will grow as you mature, and your cords can stretch to a certain point (depending on how long they were to begin with) to reach a bigger range.

One of the ways that singers injure their voices is singing songs in ranges that are not compatible with their vocal cords/instrument (vocal cords are your instrument)! Singing outside of your natural range can cause strain on your cords and further injure your voice (nodes, polyps, and more can occur).

It's best to start singing songs in a middle range, then work your way up and down throughout your training. When your voice really rings and you don't feel any tension or strain, you have found your tessitura. Keep in mind, singers often don't feel like their voice has "settled" into their tessitura until mid to late high school, or college so be patient!!

Rule of thumb: You should never feel pain in your throat, neck, back, or face when you sing. The only tension should be in using your abdominals for support!

To help you better identify your voice type, the main voice types in singing are listed below. Voice types are listed Highest to Lowest. Approximate ranges are on the following page.

Female Voice Types

Coloratura Soprano -a type of operatic soprano voice who specializes in music with leaps, runs and trills.

Lyric Soprano -a very agile, light voice with a high range, capable of very fast coloratura; bel canto roles were written for this voice.

Dramatic Soprano -a coloratura soprano of great flexibility in high velocity passages, with great sustaining power. A powerful, rich voice, able to be heard over an orchestra. This voice type takes the longest to develop.

Mezzo-Soprano -means "middle" soprano, with a darker color and the ability to extend the range.

Contralto (alto) - is the deepest female classical voice, falling between tenor and mezzo-soprano.

Male Voice Types

Countertenor- a male singing voice whose vocal range is equivalent to a contralto, mezzo-soprano or soprano.

Lyric Tenor- a light, agile tenor with the ability to sing difficult passages of high velocity.

Dramatic Tenor- a tenor with the brightness and height of a lyric tenor but a heavier vocal weight which can be "pushed" to dramatic climaxes.

Baritone- a type of male singing voice that lies between bass and tenor voices; the most common male voice.

Bass/Baritone- a voice that is richer and fuller and sometimes harsh, with a darker quality.

Bass (Basso Profundo)- a deep, heavy bass voice with an exceptionally low range; the lowest bass voice type.

Female Voice Type Ranges

Below is a description of the most common female voice types and their tessituras (<u>approximate</u> ranges). They are listed in order from highest voice type to lowest voice type. Specific ranges vary from person to person. The numbers after the note name indicate which pitch it is on the piano. For instance, C4 is the 4th C you find if you start counting from the bottom (low notes/left side) of the piano. So, (C4 = Middle C).

Coloratura Soprano

A3 - D6

Lyric Soprano

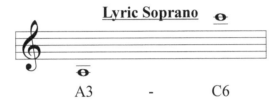

A3 - C6

Dramatic Soprano

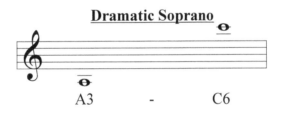

A3 - C6

Mezzo-Soprano

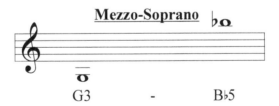

G3 - B♭5

Contralto (alto)

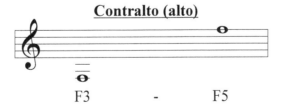

F3 - F5

Male Voice Type Ranges

Below is a description of the most common male voice types and their tessituras (<u>approximate</u> ranges). They are listed in order from highest voice type to lowest voice type. Specific ranges vary from person to person.

Countertenor

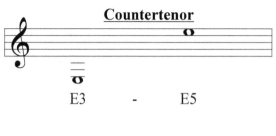

E3 - E5

Lyric Tenor

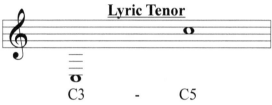

C3 - C5

Dramatic Tenor

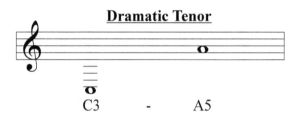

C3 - A5

Baritone

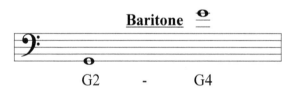

G2 - G4

Bass/Baritone

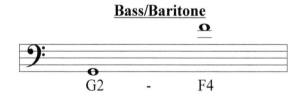

G2 - F4

Bass (Basso Profundo)

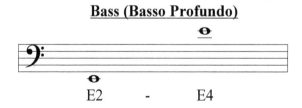

E2 - E4

Review: Lesson 9

1. Match the following voice classifications with their definitions.

a. Coloratura Soprano

_____ (F) a very agile, light voice with a high range, capable of very fast coloratura; bel canto roles were written for this voice.

b. Lyric Soprano

_____ (M) a light, agile tenor with ability to sing difficult passages of high velocity.

c. Dramatic Soprano

_____ (M) a deep, heavy bass voice with an exceptionally low range, the lowest bass voice type.

d. Mezzo Soprano

_____ (M) a tenor with the brightness and height of a lyric tenor but a heavier vocal weight which can be "pushed" to dramatic climaxes.

e. Contralto (alto)

_____ (F) a type of operatic soprano voice who specializes in music with leaps, runs and trills.

f. Countertenor

_____ (M) a type of male singing voice that lies between bass and tenor voices-the most common male voice.

g. Lyric Tenor

_____ (F) meaning "middle" soprano, with a darker color and ability to exten the range.

h. Dramatic Tenor

_____ (M) a voice that is richer and fuller and sometimes harsh, with a darker quality.

i. Baritone

_____ (F) the deepest female classical voice, falling between tenor and mezzo-soprano.

j. Bass/Baritone

_____ (M) a male singing voice whose vocal range is equivalent to a contralto, mezzo soprano or soprano.

k. Bass (Basso Profundo)

_____ (F) a coloratura soprano of great flexibility in high velocity passages, with great sustaining power. A powerful, rich voice, able to be heard over an orchestra. This voice type takes the longest to develop.

Lesson 10: Vocal Diction & IPA

Every time we sing a song, we are telling a story. As singers, we have to be exceptionally clear with how we pronounce the words of our songs, or our audience will not understand us and our story will not be told.

If you reference a dictionary in any Latin based language (English, Italian, French, German, Spanish, Latin, etc.) you will see some symbols next to the words. These symbols make up the International Phonetic Alphabet, or IPA. The IPA represents the sounds of a language. In fact, the IPA represents nearly any vowel or consonant made by human beings!

In this lesson, we'll focus on a few of the sounds in the IPA. You will learn what the letter looks like in our language, what the IPA symbol for that letter is, and what it sounds like. The IPA symbols from Levels 1-6 will also be in a chart on the following page.

Before we look at the symbols, make a couple of sounds so you can see all of the different positions your tongue moves to in order to make each sound.

Say "ah" as in the word "father," and "ee" as in the word "meet." You'll notice that when you say "ah," your tongue is at the bottom of your mouth, and when you say "ee" the center of your tongue moves to the roof of your mouth, while the tip remains down and behind the bottom teeth. When singing, we must be aware of any tension in our tongue, and ensure that it is in the proper position for creating accurate vowel sounds.

Here is a chart of the sounds we will learn in this lesson, along with their english equivalent.

ã	on (but with nasal sound)	[ɑn]	Back of tongue is high Tip behind bottom teeth Lips tall slightly rounded
ɛ̃	land (but with nasal sound)	[lænd]	Tongue is flat and wide Tip behind bottom teeth Lips spread horizontally
ʒ	vision	[vɪʒn]	Sides of tongue touching teeth in middle of mouth Lips slightly rounded

courtesy of Sarah Sandvig

Practice saying the sounds above, and the english words in the second column.

Check that your tongue and lips are in the position described in the last column.

Below is a chart of the vowels introduced in Levels 1, 2, & 3.

Practice looking at each symbol, then say the english word and pay attention to the tongue and lips position described in the third column.

IPA SYMBOL	SOUND IN ENGLISH WORD	IPA SPELLING OF WORD	TONGUE/LIPS PLACEMENT
i	ski	[ski]	Center of tongue is high Lips relaxed
ɛ	led	[lɛd]	Low tongue Lips relaxed
ɑ	father	[ˈfɑðər]	Low tongue Lips relaxed
o	obey	[oʊˈbeɪ]	Low tongue, tip behind bottom teeth Rounded lips
u	goose	[gus]	Low tongue, tip behind bottom teeth Rounded lips
ɪ	kit	[kɪt]	High tongue, sides touching top teeth Lips relaxed
e	ate	[eɪt]	High tongue, sides touching top teeth Lips relaxed
ə	afraid	[əˈfreɪd]	Mid tongue, tip behind bottom teeth Lips relaxed
æ	cat	[kæt]	Mid tongue, tip behind bottom teeth Lips slightly horizontal
ʊ	book	[bʊk]	Low tongue, tip below bottom teeth Lips relaxed & slightly pouted
ʌ	strut	[strʌt]	Low tongue, tip behind bottom teeth Lips relaxed
ɔ	forest	[fɔrəst]	Low tongue, tip behind bottom teeth Lips slightly rounded

Note: The schwa (ə) and the "uh" vowel (ʌ) are very similar. The schwa (ə) is unaccented and not stressed, while the (ʌ) is open and emphasized, like in the words "money or "under."

Below is a chart of the vowels and consonants introduced in Levels 4-6, and the new ones for Level 7. Practice looking at each symbol, then say the english word and pay attention to the tongue and lips position described in the third column.

oʊ (diphthong: 2 vowel sounds)	goat	[goʊt]	Low tongue, tip behind bottom teeth Lips open then rounded
aɪ (diphthong: 2 vowel sounds)	price	[praɪs]	Low tongue then high tongue tip behind bottom teeth then sides touching top teeth Lips tall then relaxed
dʒ	jar	[dʒɑr]	High tongue on hard palate tip behind top teeth Lips rounded
ʎ	million (but keep tongue flat, and tip behind top teeth)	[mɪljən]	High, flat tongue tip behind top teeth Lips relaxed
ʃ	ship	[ʃɪp]	High tongue sides touching top teeth Lips rounded
ɲ	canyon	[kaɲjon]	High tongue Tip touching hard palate Lips relaxed
h	ham	[hæm]	Low, flat tongue Open, wide mouth Lips relaxed
ŋ	sing	[sing]	High tongue Middle touching soft palate Lips relaxed
ð	this	[ðɪs]	Mid tongue Tip between teeth Lips relaxed
ç	hue	[çju]	High tongue Middle touching hard palate sides touching top teeth Lips relaxed
x	loch (but don't let tongue touch the roof of your mouth)	[lɑx]	High tongue back arched towards soft palate with air Lips open, slightly rounded
ts	bats	[bæts]	Low tongue Tip between front teeth Lips relaxed
aʊ (diphthong: 2 vowel sounds)	shout	[ʃaʊt]	Low tongue then high tongue tip behind bottom teeth then sides touching top teeth Lips tall then rounded
ã	on (but with nasal sound)	[ɑn]	Back of tongue is high Tip behind bottom teeth Lips tall slightly rounded
ɛ̃	land (but with nasal sound)	[lænd]	Tongue is flat and wide Tip behind bottom teeth Lips spread horizontally
ʒ	vision	[vɪʒn]	Sides of tongue touching teeth in middle of mouth Lips slightly rounded

Review: Lesson 10

1. Check the English word that contains the same sound as the given IPA symbol.

ã	___Cats ___Pond	ð	___Lot ___Thine	ʃ	___Shut ___Soft	oʊ	___Loot ___Float	æ	___Fat ___Faint
ɛ̃	___Hand ___Box	ŋ	___Thing ___Never	j	___Yellow ___Jump	ɔ	___More ___Boat	ə	___Meet ___Around
ʒ	___Measure ___Buzz	h	___Hard ___Hear	ʤ	___Dad ___Just	ʌ	___Vote ___Mutt	e	___Plate ___Bet
aʊ	___Route ___Bat	ɲ	___Nick ___Canyon	aɪ	___Rice ___Rate	ʊ	___Book ___But	ɪ	___Fit ___White
ç	___Honor ___Heat	o	___Over ___Pot	ɑ	___Bat ___Bother	ɛ	___Greed ___Met	i	___Free ___Bit
		ts	___Bats ___Toad	x	___Hoch ___Fox	u	___Goose ___Rut		

2. Write a word in the blank provided that uses the given IPA sound. Don't use any of the words from above or on the previous pages!

ɲ _____	ã _____	ɛ̃ _____
aʊ _____	ð _____	ʃ _____
ts _____	ŋ _____	j _____
x _____	h _____	ʤ _____
ç _____	ʒ _____	aɪ _____
u _____	o _____	ɑ _____
oʊ _____	ʊ _____	ə _____
ɔ _____	ɛ _____	e _____
ʌ _____	æ _____	ɪ _____

Lesson 11: Italian, Latin, Spanish, German & French Diction

When you first learn a song in a foreign language, Italian and Latin are two of the easier languages to pronounce. Below are some rules for speaking/singing words in Italian and Latin that can help you learn how to prounounce the text in your songs.

It's also a great idea to use a translation app or website to hear someone pronounce the foreign language text as well.

Italian/Latin Diction

As with any language, practicing speaking this language with an Italian accent will help with pronunciation. IPA is included in parentheses after each Italian/Latin word.

Remember: No diphthongs!
•*Core* (kore) is pronounced <u>Core-A</u>, but without the E sound at the end of A.
Another example is *Mio* (mˈio) is pronounced <u>Mee-oh</u> but without the oo sound and the end of O.

•I's are pronounced like E's. (ie) *Ma'mi* (mami) is pronounced <u>Mamee</u>

•All R's are rolled or flipped. If you cannot roll your R's, try something similar to a D. *Caro* (karo) would sound similar to *Cah-doh*, then add a little less pressure to the roof of your mouth. Your tongue touches the top of your hard palate behind your top front teeth for the first letter.
**Two great practice exercises to learn how to roll your tongue is to say "Podda tea" over and over again, or try saying"Tah-dah" over and over again.

•A "C" followed by an E or I is pronounced as a "CH." (ie) *Facil* (fatʃil) is pronounced <u>Facheel</u>.
 Also *Dolce* (doltʃe) is pronounced <u>Dole-cheh</u>.
•A "CH" combo is pronounced as a K. (ie) *Chiaro* (kjaro) is pronounced <u>Kee-ah-ro</u>.

•When a word has a double consonant, you stop on the first consonant then continue. The best example of this is the word "*Pizza*" (piddza). It's not pronounced PEEZA, it's pronounced <u>PEETSA</u>.
 Also *Quella* (kwella) is <u>Kwell-lah.</u>

•A "G" if it's before an e or an i is a soft g. (ie) *gentil* (dʒentil) is pronounced <u>jenteel, *Giardi* (dʒardi) is</u> pronounced <u>Jar-dee</u>. Notice the "i" is silent when it falls between G and another vowel. The same rule applies when an "i" falls between C and another vowel as in "*ciao*." <u>ch-ow</u>
•A "G" followed by an "L" is silent. (ie) *scegliera* (ʃeʎʎera) is pronounced <u>shay-lee-err-ah</u>.
•A G followed by an H is pronounced as a Hard G…*Lunghezza* (luŋgettsa) is pronounced <u>Loon-get-tsa.</u>

•*Que* (kwe) is pronounced <u>Kway.</u>
•*Che* (ke) is pronounced <u>Kay.</u>

•An S followed by a C is pronounced as an SH. (ie) *s'angoscia* (ssaŋgoʃʃa) is <u>san-go-shah.</u>
•If an S is followed by a CH it's pronounced as SK. (ie) *scherzosa* (skertsoza) is <u>scare-tso-za.</u>
•A single S between two vowels is pronounced as a Z. (ie) *ascosa* (askoza) is pronounced <u>ah-sko-za</u>
•An SC before e or i is pronounced as an SH. (ie) *scegliera* (ʃeʎʎera) is pronounced <u>shay-lee-err-ah</u>

•An H at the beginning of a word is silent. (ie) *Hanno* (anno) is pronounced <u>Ahn-no.</u>

•A Z is pronounced like TS. (ie) *Danza* (dantsa) is pronounced <u>Dawn-tsa.</u>

•An "A" is pronounced as an "AH"

Spanish Diction

When singing in Spanish, pay special attention to where the composer is from. Spanish pronunciation differs slightly depending on the country. It's always best to listen to a recording, if possible, of a singer or speaker who is from the same country as the composer.

Remember: No diphthongs!

Noche is pronounced <u>No-chay</u>, but without the E sound at the end of A.

Another example is *Mio* is pronounced <u>Mee-oh</u> but without the oo sound and the end of O.

•Roll all R's that begin a word.
•Flip all R's at the end of a word.
•Roll or flip all R's in the middle of a word depending on how it is usually pronounced.

•The "C" sound is different in Spanish from Spain as opposed to Spanish from Mexico and other countries. The Spain "C" is pronounced with a th sound like a lisp (ie) *hacer* is pronounced <u>Hather.</u> In Mexico, it's just an "S" sound (ie) *hacer* is pronounced <u>Ha-ser.</u>

•Double LL's are pronounced as a Y. (ie) *Llega* is pronounced <u>Yeah-gah.</u>

•T's and D's use a flatter tongue, more dentalized. These two consonants are not as bright as we say them in English. Example: *todos* is <u>toe-those,</u> and **not** <u>toe-dohs.</u>

•Pay special attention to accents, and pronounce them as spoken.

•Pronounce J's with a small puff of air, in order for it to be audible, similar to an H. (ie) *Reja* is pronounced <u>Ray-ha.</u>

•Always hold the first vowel when singing a word with a diphthong.

•*Que* is pronounced as <u>Kay.</u>
•*Che* is pronounced as <u>Chay.</u>

•An ñ is pronounced as in the word Ke**nya**.

•A Y (the letter that stands for the word "and") is pronounced as an E, as in "key."

•E's are pronounced as the IPA symbol "e" as in "Pay" when in the <u>middle</u> of a word.
•E's are pronounced as the IPA symbol "ɛ" as in "let" when at the <u>beginning</u> of a word.

•I's are pronounced as E's. *Mi* is pronounced as <u>Mee.</u>

•G followed by an i or e is pronounced with the H sound like *gente* <u>hente</u> or *Ginastera* <u>Hinastera.</u>
•G followed by a u is a hard G as in *gusta* <u>goos-tah</u>

German Diction

As with any language, practicing speaking this language with a German accent will help with pronunciation.

*In German, vowel combinations will form sounds similar to diphthongs. "Blau" is pronounced Blah-oo. Much like the sound in the word "**Ou**ch."*

•W's are pronounced as V's. (ie) *Werden* is pronounced Vair-duhn.

•V's are pronounced as F's. (ie) *Vater* is pronounced Faht-uh.

•IE combinations are pronounced as an E. (ie) *Lied* is pronounced Leed.

•EI combinations are pronounced as an I. (ie) *Mein* is pronounced Mine.

•E's at the ends of words are open, using the same sound as a schwa (ə). *liebe* = Lee-buh.

•ü is called an Umlaut (the two dots above a vowel). If you see this over a "u" form an "oo" with your lips, and say an "E." Think of saying "ee" on this inside.

•ä is prounounced like an A as in Maid. (ie) *Mädchen* is pronounced Met-hun.

•ö is pronounced as in the word "hurt" but with an open R. (ie) *öffnen* = erf-nen.

•A Z at the beginning or end of a word is pronounced as a TS. (ie) *Zart* is pronounced Ts-art., *Herz* is pronounced Hair-ts

•A "D" at the end of a word, or when followed by another consonant at the end a root stem is pronounced as a T. (ie) *Und* is pronounced Oont. (ie) *Bildnis* is pronounced Built-niss

•A "D" at the beginning of a word or followed by a vowel is pronounced as a D. *Kinder* =Kin-duh.

•A "B" at the end of a word is pronounced as a P. (ie) *Selb* is pronounced Zelp.

•A CH at the end of a word is pronounced with a lot of air, much like the sound of a hissing cat, as in the word *ich.**

•Roll or flip all R's in the middle of a word. Open R's at the end of words, using the same sound as a schwa (ə). (ie) *immer* is pronounced imm-uh.

•S's followed by a consonant is sounded as an SH. (ie) *stehn* is pronounced Shtain.

•S's followed by a vowel are pronounced as a Z. (ie) *sei* is pronounced Z-ah-ee (rhymes with high)

•E's are pronounced like an A as in Ate. (ie) *den* is pronounced Dane.

•J's are pronounced as a Y. (ie) *Jäger* is pronounced Yay-guh.

•ß is a double S, "SS"

*The CH sound at the ends of words varies depending on what part of Germany you are from. Some pronounce it with a high middle tongue and similar to the hissing of a cat, others pronounce it more like a "shh." Whatever you choose, remain consistent in your German repertoire.

French Diction

As with any language, practicing speaking this language with a French accent will help with pronunciation.
All R's are forward and flipped when singing French. No back R's as when speaking French.

Remember: No diphthongs: "Les" is Lay without the e sound at the end.

**Much of French involves nasal sounds. You do not pronounce a lot of the ends of words. Instead you end them with a nasal sound. (ie) "Dans"= Don (without closing the N-touching the back of your tongue to the roof of your mouth). Nasals in IPA are indicated by a squiggly line: ã this is called a "tilde."

•Ends of words that are not pronounced are "s" "eil" "iens" "t" "ent" "ng" •Sommeil=Somay Tes-Tay Rayonnais=Ray-oh-nay
•You do pronounce some endings of words if the following word starts with a vowel.
(vous avez)- is pronounced Voo-zAh-vay

•An E at the end of a word is the neutral vowel (schwa) much like "uh" (ie) *image*=E-mah-j
(g is pronounced like the S sound in the word measure). Other endings of words that have the neutral sound are: Es, eurs, re, ge, le, se
(When spoken, you do not say the schwa at the end of a word, but when singing, the final syllable is typically under a note that must be sung.)

•If an X is at the end of a word and followed by a word that starts with a vowel, it's pronounced as a Z. (ie) *yeux etaient* = Yoo-zA-tay

•The combination *heur* is like saying "earth" (with an open R and a dropped jaw)
(ie) *l'heur* = lehr (with a dropped jaw)

•An accent over an e that is pointing up to the right is pronounced as an A.
(ie) Hélas=A-lass

•U's have an E sound in them. (ie) *nues* = new-uh

•Some ends of words are pronounced as an A. (ie) "ais" and "aient"

•*Oi*=W (as in *oui*-we) *Toi*=Twa *Voix*=vwa

•An I at the beginning of a word is nasal. *Incline*=Un-clean (without closing the first n).

•An N proceeded by a vowel is nasal. (ie) *Long*=Lon (Nasal N without closing it).
 (ie) *Silence*=See-lon-s (again without closing the N).

•An X at the end of a word is an Oh sound. (ie) *berceaux*=bare-so

•H's are silent (ie) *Hélas*=A-lass.

•*Qui*=Key

Review: Lesson 11

1. For the following questions, check the correct choice that best describes how the Italian, Latin, Spanish, German or French words would be sung.

French

Mes ___Mess
 ___May

Fui ___Few-ee
 ___F-why

Votre ___Voh-truh
 ___Voh-tray

Une ___Yoon
 ___Ew-oon

Jour ___Joor
 ___J-ower

Comme ___Comma
 ___Comb-ah

Que ___Kay
 ___Kuh

Dans ___Dah
 ___Dons

C'est ___Set
 ___Say

German

Wie ___Wee
 ___Vee

Das ___Daze
 ___Doss

Liebchen ___Leap-chen
 ___Lye-pen

Singet ___Sing-eet
 ___Zing-et

Und ___Oond
 ___Oont

Linde ___Lean-day
 ___Lin-duh

Ver ___Vare
 ___Fair

Braut ___Bright
 ___Browt

Springen ___Shh-pring-un
 ___Spring-en

Spanish

Que ___Kway
 ___Kay

Majo ___Ma-joh
 ___Ma-hoe

Hombre ___Home-bree
 ___Om-bray

Discreto ___Dee-skret-oh
 ___Diss-creat-oh

Muerto ___Moo-urt-oh
 ___Mwer-toh

Llega ___Lay-ga
 ___Yea-gah

Mujer ___Moo-hair
 ___Muh-jare

Cual ___Kw-all
 ___Coo-ail

Muy ___Muh-why
 ___Moo-ee

Italian/Latin

Questo ___Kwesto
 ___Kesto

Più ___Pie-oo
 ___Pew

Diletto ___Dye-letto
 ___Dee-let-toh

Piacer ___Pya-chair
 ___Pie-a-sir

Voglio ___Voh-lee-oh
 ___Vog-lye-oh

Care ___Sare-eh
 ___Car-eh

Senza ___Zen-za
 ___Sen-tsah

Fai ___Fay
 ___Fa-ee

Dolce ___Dole-chay
 ___Dole-say

Lesson 12: Sight-Singing

In order to learn a song, singers learn to read both rhythmic patterns and notes (melody) on the staff. Singing a melody for the first time is called "sight-singing." Below are some rhythmic examples using the notes introduced so far.

Hint: When singing rhythmic examples, take a breath on the rests: then you won't miss them!
Tap and *say* the beats, then sing the examples on La (choose any pitch that suits your voice).

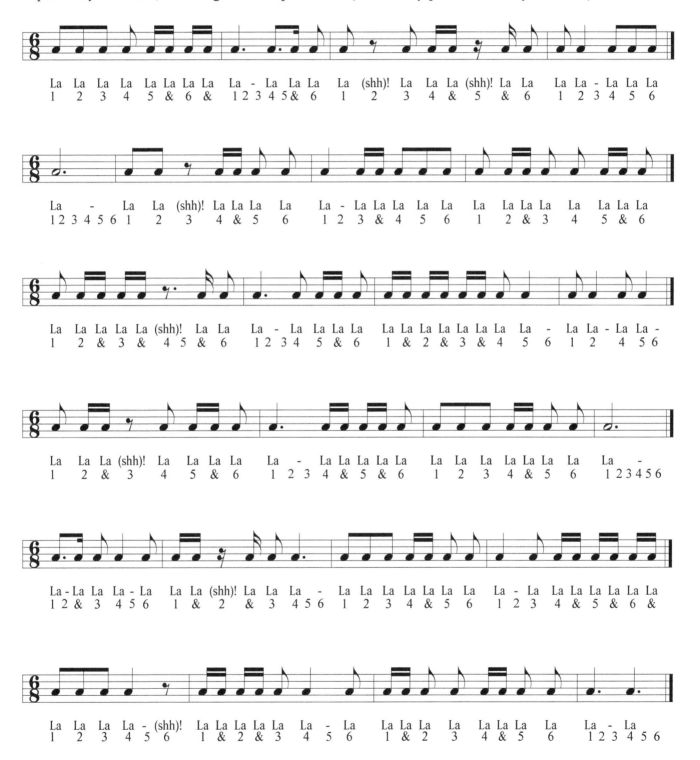

Melody & Solfege

Solfege is a system of assigning a syllable to each note of a scale, just like in the song "Do-Re-Mi" from the musical *The Sound of Music*.

Solfege is a useful tool when sight-singing. Moveable "Do" is when "Do" matches the **root** of whatever key you're in.

In this level you will be introduced to melodies in a natural minor key, in the range of an octave. When singing a Natural minor scale, the solfege is slightly different. The 3rd, 6th & 7th notes are lowered, so the solfege changes. The altered solfege represents the different notes and sounds that are in a minor scale.

Solfege for an ascending minor scale is: Do-Re-Me-Fa-Sol-Le-Te- Do. You may also use the solfege that relates to the relative Major key: La-Ti-Do-Re-Mi-Fa-Sol-La. The following melodies are all minor.

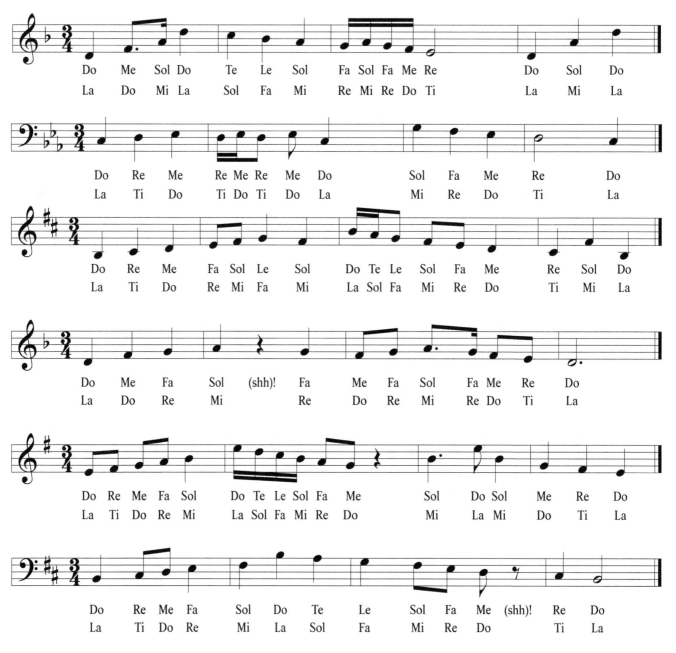

(Me is pronounced "May," Le is pronounced "Lay," Te is pronounced "Tay.")

Review: Lesson 12

1. For the following melodies, write the note names, solfege & beats underneath the notes.
 Pay special attention to the key signature (Major or minor). Choose either "moveable Do" (where Do is the root of the minor key) or use the solfege as it relates to the Major key. Both examples have been provided for you. Practice singing the examples when you are done!

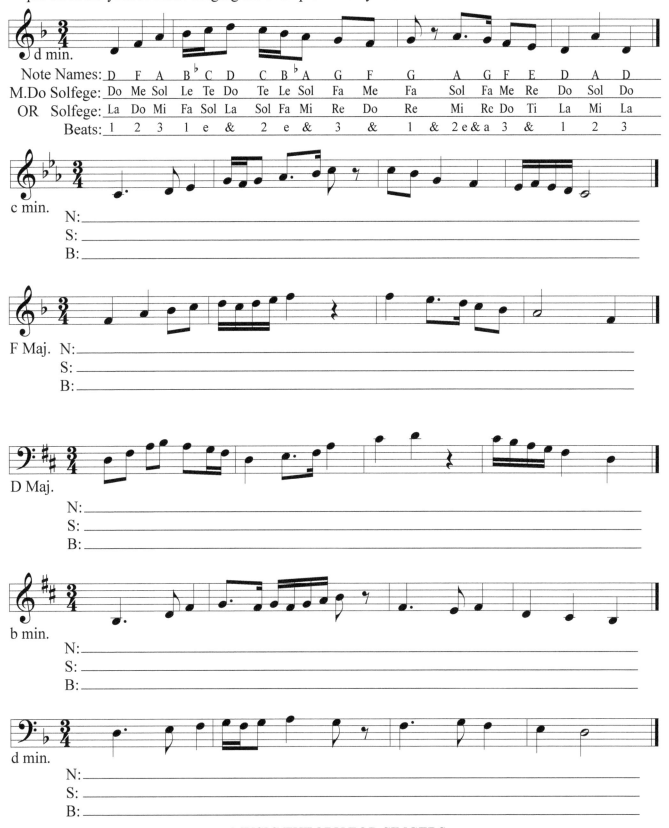

Note Names:	D	F	A	B♭	C	D		C	B♭	A	G	F		G		A	G	F	E		D	A		D
M.Do Solfege:	Do	Me	Sol	Le	Te	Do		Te	Le	Sol	Fa	Me		Fa		Sol	Fa	Me	Re		Do	Sol		Do
OR Solfege:	La	Do	Mi	Fa	Sol	La		Sol	Fa	Mi	Re	Do		Re		Mi	Re	Do	Ti		La	Mi		La
Beats:	1	2	3	1	e	&		2	e	&	3	&		1	&	2	e	& a	3	&	1	2		3

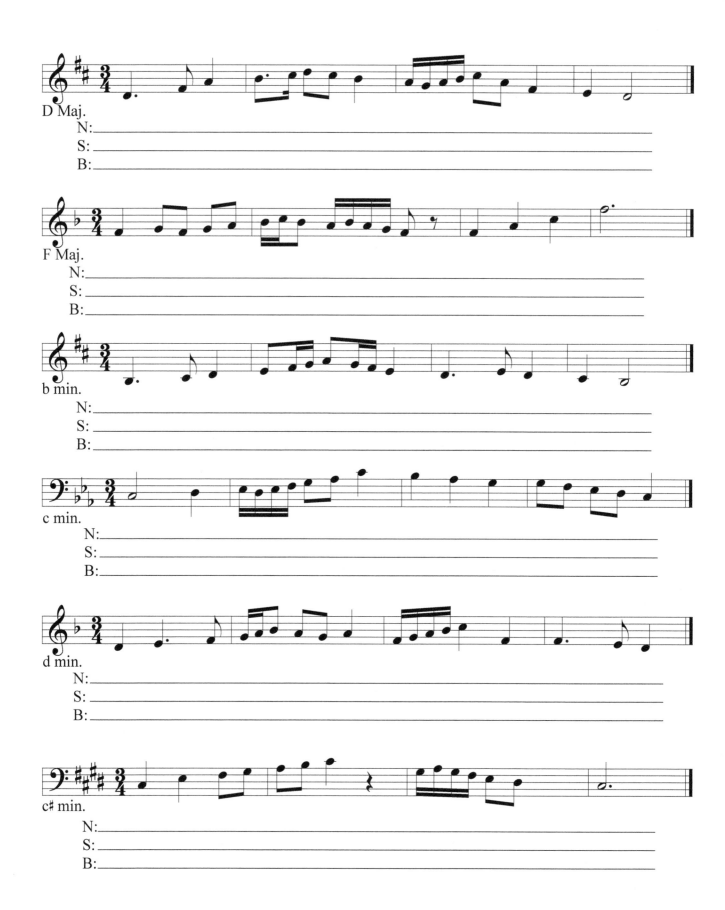

D Maj.

N: _____

S: _____

B: _____

F Maj.

N: _____

S: _____

B: _____

b min.

N: _____

S: _____

B: _____

c min.

N: _____

S: _____

B: _____

d min.

N: _____

S: _____

B: _____

c# min.

N: _____

S: _____

B: _____

Lesson 13: Musical Terms

A crucial part of understanding music is being able to recognize and define musical terms. Below is a list of terms covered in this level.

animé - (Fr.) moderately fast, animated

appoggiatura - (♪) an accented, non-harmonic note that resolves stepwise to a harmonic note, often written in small type but receiving its full value, taken from the note of resolution

aria - a song for solo voice within an opera or oratorio

cadence - the series of notes or chords that ends a melody or section, giving the listener a sense of finality

cadenza - a solo passage, often technically difficult, usually near the end of a piece, either written by the composer or improvised by the performer

chanson - (Fr.) song

chromatic - moving by half steps

doucement - (Fr.) gently, softly

enharmonic - two notes that have the same pitch but different names

imitation -a compositional technique consisting of the overlapping repetition of a melody by two or more "voices"

IPA- the International Phonetic Alphabet: a standard representation of the sounds of spoken language

léger - (Fr.) light and fast

lentement - (Fr.) slowly

libretto - the text, whether spoken or sung, of a dramatic vocal work

misterioso - mysteriously

modéré - (Fr.) moderately

mordent- (♪) an ornament where the main note and the note below are sung quickly in succession before returning to the main note.

portamento - a smooth glide from one note to another

recitative - a vocal number that mimics the inflections of speech, found primarily in operas & oratorios

rubato - freely speeding up or slowing down the tempo without changing the basic beat

triste - (Fr.) sad

vite - (Fr.) fast

Review: Lesson 13

1. Check the appropriate answer for each of the following questions.

a. This is an accented, non-harmonic note that resolves stepwise to a
 harmonic note, often written in small type.

 ___mordent
 ___appoggiatura

b. This term means "song" in French.

 ___lied
 ___chanson

c. This is the name for the text, whether spoken or sung, of a dramatic
 vocal work.

 ___libretto
 ___oratorio

d. This means "slowly" in French.

 ___langsam
 ___lentement

e. This term means a smooth glide from one note to another.

 ___portamento
 ___staccato

f. This is an ornament where the main note and the note below are sung
 quickly in succession before returning to the main note.

 ___mordent
 ___appoggiatura

g. This term means freely speeding up or slowing down the tempo
 without changing the basic beat.

 ___accelerando
 ___rubato

h. This means "sad" in French.

 ___triste
 ___lentement

i. This is a series of notes or chords that ends a melody or section,
 giving the listener a sense of finality.

 ___cadence
 ___double bar line

j. This is a vocal number that mimics the inflections of speech, often
 found at the beginning of an aria in Operas or Oratorios.

 ___recitative
 ___libretto

k. This term means two notes that have the same pitch but different names.

 ___accidentals
 ___enharmonic

2. Complete the following crossword puzzle using the terms from this level.

Level 7 Crossword

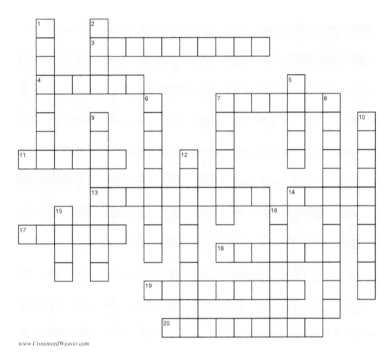

www.CrosswordWeaver.com

ACROSS

3 a vocal number that mimics the inflections of speech, found primarily in operas and oratorios

4 freely speeding up or slowing down the tempo without changing the basic beat

7 a solo passage, often technically difficult, usually near the end of a piece, either written by the composer or improvised by the performer

11 (Fr.) moderately

13 mysteriously

14 (Fr.) light and fast

17 (Fr.) sad

18 an ornament where the main note and the note below are sung quickly in succession before returning to the main note.

19 (Fr.) slowly

20 (Fr.) gently, softly

DOWN

1 the text, whether spoken or sung, of a dramatic vocal work

2 a song for solo voice within an opera or oratorio

5 (Fr.) moderately fast, animated

6 a compositional technique consisting of the overlapping repetition of a melody by two or more "voices"

7 (Fr.) song

8 an accented, non-harmonic note that resolves stepwise to a harmonic note, often written in small type

9 moving by half steps

10 two notes that have the same pitch but different names

12 a smooth glide from one note to another

15 (Fr.) fast

16 the series of notes or chords that ends a melody or section, giving the listener a sense of finality

Lesson 14: Spotlight on Composers

An important part of music education is learning about the history of music. Studying composers allows for understanding the music we sing and why it was written the way it was. In this level, you will learn about Enrique Granados, Gabriel Fauré & Aaron Copland.

ENRIQUE GRANADOS

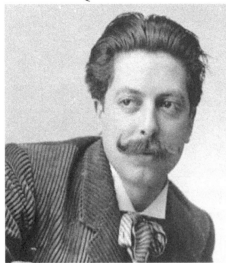

Courtesy of Library of Congress

Enrique Granados was born in the Late Romantic/Impressionist period of music, on July 27, 1867 in Lleida, Spain. He studied piano in Barcelona and Paris when he was young. He published his Danzas Españolas in 1889, which brought him international recognition.

Granados gave many concerts in Spain, France and New York. He wrote chamber music, vocal music, operas, symphonic poems and piano works. In 1898, Granados premiered his first zarzuela (Spanish opera) *Maria del Carmen*. A zarzuela is a Spanish Opera with alternating spoken and sung scenes.

In 1901, Granados founded the Academia Granados in Barcelona, Spain. Many famous musicians came out of this academy including Paquita Madriguera, Conchita Badia and Frank Marshall. In 1916, Granados's opera *Goyescas* (a piano suite converted into an opera) premeiered at the Metropolitan Opera in New York. In this same year, he also performed at the White House for president Woodrow Wilson.

Tragically, on March 24, 1916, Granados and his wife were traveling across the English Channel, (Granados was terrified of the water), when a German torpedo hit the boat. Granados tried to save his wife, but they both drowned. They left six children.

Best Known Vocal Works:
Maria del Carmen (1898-Opera), ***Goyescas*** (1916-Opera), ***Tonadillas al estilo antiguo*** (for voice and piano), ***Canciones Españolas*** (for voice and piano)

Vocal Songs:
"El Majo Discreto," "La Maja Dolorosa," "El mirar de la Maja," "El tra-la-la y el Punteado"

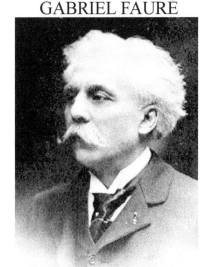

GABRIEL FAURÉ

Gabriel Fauré was born in the Late Romantic/Impressionist/ Early 20th Century period of music on May 12, 1845 in France. As a child, he was a gifted pianist and was sent to the École de Musique Classique et Religieuse (School of Classical and Religious Music) in Paris. During the 11 years at the school, he studied with such famous musicians as Niedermeyer, and Camille Saint-Saëns, who became a life-long friend.

After leaving the school, Fauré became the organist at the Church of Saint-Sauveur in Brittany and also gave private piano and organ lessons (his two main performance instruments). He also served in the military for a brief time before he was appointed choirmaster at the Église Saint-Sulpice. He also attended Saint-Saëns musical salon gatherings, joining the Société Nationale de Musique. Other members of this famous Society were Georges Bizet, Henri Duparc, César Franck, and Jules Massenet. Many of his works were first heard at the society's concerts.

Michael Nicholson/Contributor/Getty

In 1877, Fauré was briefly engaged to Marianne Viardot, then he traveled a great deal to Germany, seeing several of Wagner's operas. Fauré married Marie Fremiet in 1883, and they had two sons. He did have several open relationships with other women, including the pianist Marguerite Hasselmans. In 1896, Fauré was appointed professor of composition at the Paris Conservatoire. He taught many young composers including Maurice Ravel, Louis Aubert and Nadia Boulanger. In 1905, he became the head of the Paris Conservatoire which helped him become more widely known as a composer. During this time, he wrote his lyric opera, *Pénélope*, and several vocal song cycles including *La chanson d'Ève.*

In 1909, Fauré was elected to the Institut de France. His music became popular in several countries including Britain, Germany, Spain and Russia. He became known as the Master of the French Art song, or "Mélodie." In 1911, he began to lose his hearing, which eventually forced him to leave his teaching position. In 1922, there was a public tribute in his honor in Sorbonne. He watched a concert of his own works, which made him very happy. He died in Paris from pneumonia on November 4th, 1924. He was 79 years old.

Best Known Vocal Works:
***Requiem**, Op.48 (1888)*, **Pénélope** *(opera 1913)*, **La Bonne Chanson** *(song cycle)*, **Cinq mélodies de Venise** *(song cycle)*, **La chanson d'Ève** *(song cycle)*

Vocal Songs:
"Clair de lune," "Le Secret," "Nocturne," "Les présents," "Les berceaux," "Les roses d'Ispahan," "Après un rêve," "Au Bord de L'eau," "Mandoline," "Ici-bas"

AARON COPLAND

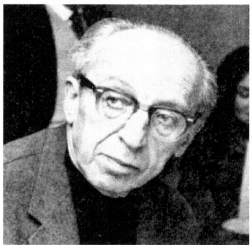

Bettmann/Contributor/Getty

Aaron Copland was born in the Contemporary period of music on November 14, 1900 in Brooklyn, New York. His sister, Laurine, first taught Aaron piano before he began formal lessons with Leopold Wolfsohn. He composed his first melody at the age of eleven and decided to become a composer by the time he was 15.

Copland studied piano (his main performance instrument), harmony, theory and composition from Rubin Goldmark, then studied later with Victor Wittgenstein. His most famous teacher in Paris was Nadia Boulanger. He studied with her for three years at the Paris Conservatory before returning to New York.

Around 1935, Copland began to compose music for young audiences including piano pieces and the opera *The Second Hurricane*. During the Depression, he traveled to Europe, Mexico and Africa and began writing one of his first famous works, *El Salón México*. In 1939, Copland finished his first two Hollywood film scores for *Of Mice and Men* & *Our Town*. He also wrote music for the ballet *Billy the Kid* that same year.

Copland became very active in the American Composers Alliance which helped collect fees pertaining to performance of composers copyrighted music. He also wrote the scores for the two ballets *Rodeo* & *Appalachian Spring* which were both successful. In 1942, he wrote the patriotic piece *Lincoln Portrait* for voice and orchestra which has become a patriotic standard along with his *Fanfare for the Common Man*.

In 1954, Copland recieved a commission from Rodgers and Hammerstein to write the music for the opera *The Tender Land*. This remains one of the few American operas in the standard repertory. Copland had a huge influence on other composers, including his friend Leonard Bernstein. When Copland was older he conducted more than composed, and he made a series of recordings.

Copland died of Alzheimer's disease and respiratory failure on December 2nd, 1990. He was 90 years old.

Best Known Vocal Works:
The Tender Land (Opera), ***The Second Hurricane*** (High School Opera), ***Twelve Poems by Emily Dickinson, Old American Songs, Canticle of Freedom***

Other Significant Works:
"The Cat and the Mouse," "Vocalise No.1" (Voice), *Billy the Kid* (Ballet), "Fanfare for the Common Man," "Lincon Portrait"

Review: Lesson 14

1. Fill in the correct answer to the following questions about Enrique Granados, Gabriel Fauré and Aaron Copland.

Enrique Granados

a. Granados was born in which country?_____

b. What music period(s) does he represent?_____

c. What is the name of the music school he founded in Barcelona, Spain?_____

d. What is the name of his first opera?_____

e. What is a "Zarzuela?"_____

f. How did Granados die?_____.

Gabriel Fauré

a. Fauré was born in which country?_____

b. What music periods does he represent?_____

c. What are his two main performance instruments?_____

d. He is regarded as the master of what genre of vocal music?_____

e. In 1909, Fauré was elected to what institution?_____

f. What is the name of the French composer who taught Fauré and became a life-long friend?

Aaron Copland

a. Copland was born in which country?_____

b. What music period does he represent?_____

c. What is the name of his famous female piano teacher from Paris?_____

d. Name his 1942 patriotic work written for voice and orchestra._____

e. Name Copland's two film scores that he completed in 1939._____&

Level 7 Review Test

Answer the questions about the following musical example. (11 points)

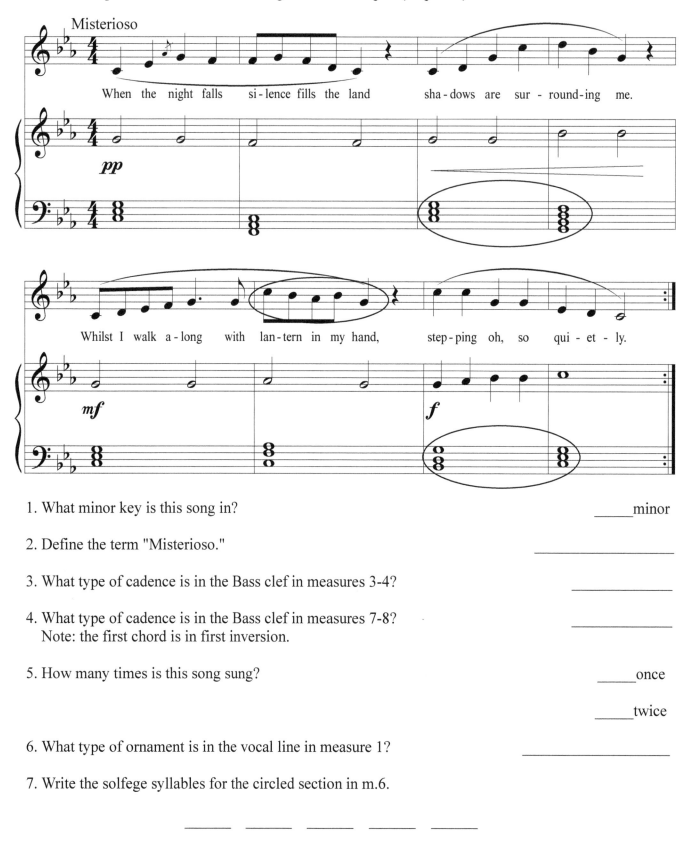

1. What minor key is this song in? _____minor

2. Define the term "Misterioso." _____

3. What type of cadence is in the Bass clef in measures 3-4? _____

4. What type of cadence is in the Bass clef in measures 7-8?
 Note: the first chord is in first inversion. _____

5. How many times is this song sung?

 _____once

 _____twice

6. What type of ornament is in the vocal line in measure 1? _____

7. Write the solfege syllables for the circled section in m.6.

 _____ _____ _____ _____ _____

8. Write an ascending and descending chromatic scale beginning and ending on middle C. (2 points, one for ascending, one for descending)

9. Write the enharmonic note after the given note for each example. (4 points)

10. Add 3 bar lines and a double bar line to the following example. (4 points)

11. Choose the missing time signature, add it to the example, then write the beats underneath the notes. (5 points-one for the time signature, one for each correct measure)

$$\frac{4}{4} \qquad \frac{3}{4} \qquad \frac{3}{8}$$

12. Name, then draw the relative minor scale in its natural form below the given Major scale. Use whole notes, ascending only. (2 points)

A♭ Major

____minor

13. Write the key signature, then draw an ascending natural minor scale in the requested keys. (4 points)

d minor

g♯ minor

14. Label the following ornaments with their correct name. (3 points)

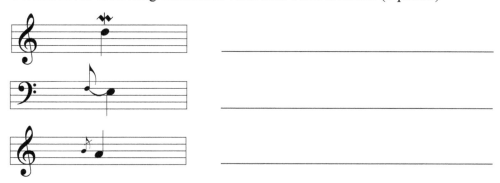

15. Label the following chord progressions with the correct Roman numerals. Make sure to pay attention to the key signatures. In the Major example, chords are shown in inversions. (8 points)

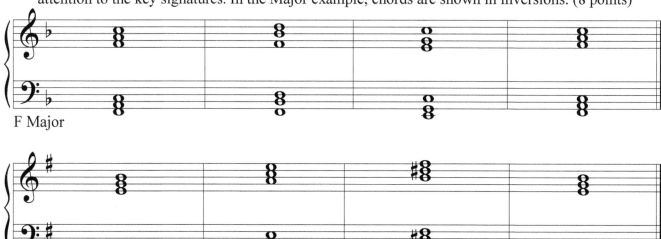

F Major

e minor

16. Draw the correct chords according to the Roman numerals given. You may need to add an accidental to the dominant chord in the minor key in order for the chords to be correct. You may use either root position or inversion chords. Pay attention to the key signatures. (8 points)

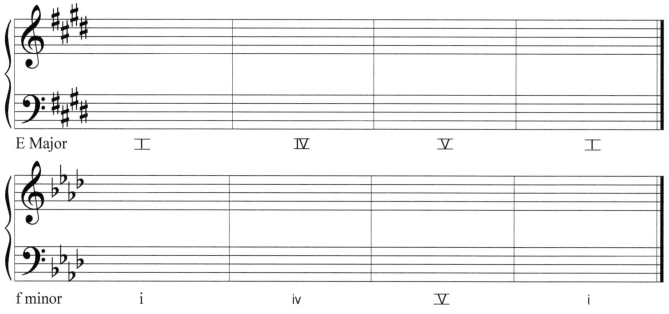

E Major I IV V I

f minor i iv V i

17. Match the cadences with their correct name. All examples are in a Major key and in Root Position (3 points)

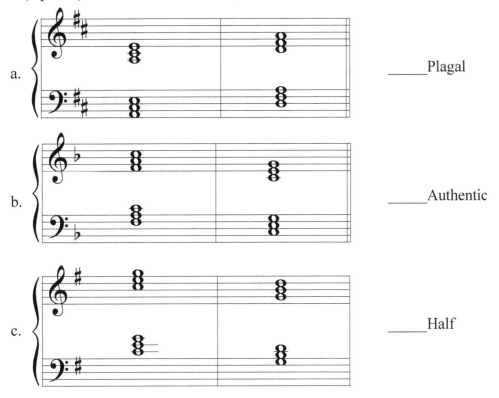

a. _____Plagal

b. _____Authentic

c. _____Half

18. Write the beats under the following rhythmic example. (4 points)

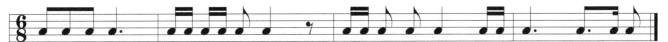

19. Write the note names and solfege under the notes in the following examples. Pay attention to the key signature. You may think of the minor root as "Do" using moveable Do, or think of the Major key signature, and the first note in the minor example would be "La" using fixed Do. Add #/♭ if necessary. (8 points)

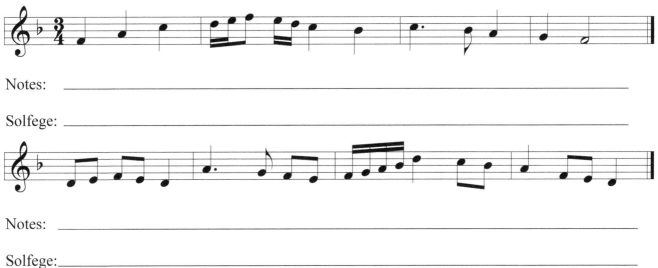

Notes: _____

Solfege: _____

Notes: _____

Solfege: _____

20. Match the voice classifications below with their definitions. (11 points)

a. Coloratura Soprano

_____ (M) a voice that is richer and fuller and sometimes harsh, with a darker quality.

b. Lyric Soprano

_____ (F) the deepest female classical voice, falling between tenor and mezzo-soprano.

c. Dramatic Soprano

_____ (M) a male singing voice whose vocal range is equivalent to a contralto, mezzo soprano or soprano.

d. Mezzo Soprano

_____ (F) a coloratura soprano of great flexibility in high velocity passages, with great sustaining power. A powerful, rich voice, able to be heard over an orchestra. This voice type takes the longest to develop.

e. Contralto (alto)

_____ (F) a very agile, light voice with a high range, capable of very fast coloratura; bel canto roles were written for this voice.

f. Countertenor

_____ (M) a light, agile tenor with ability to sing difficult passages of high velocity.

g. Lyric Tenor

_____ (M) a deep, heavy bass voice with an exceptionally low range, the lowest bass voice type.

h. Dramatic Tenor

_____ (M) a tenor with the brightness and height of a lyric tenor but a heavier vocal weight which can be "pushed" to dramatic climaxes.

i. Baritone

_____ (F) a type of operatic soprano voice who specializes in music with leaps, runs and trills.

j. Bass/Baritone

_____ (M) a type of male singing voice that lies between bass and tenor voices-the most common male voice.

k. Bass (Basso Profundo)

_____ (F) means "middle" soprano, with a darker color and ability to extend the range.

21. Check the English word that contains the same sound as the given IPA symbol. (4 points)

ɲ ___Yellow ɛ̃ ___Grand
___Onion ___Bet

ɑ̃ ___Fond ʒ ___Beige
___Fat ___Zebra

22. For the following questions, check the correct choice that best describes how the French word would be pronounced. The IPA spelling is provided for you, in parentheses, after the word. (4 points)

dans (dɑ̃) ___don (with open n) une (yn) ___un
___dan (with open n) ___oon

je (ʒə) ___jay (soft j) blanche (blɑ̃ʃ)___blah-shuh
___juh (soft j) ___blach-ee

23. Fill in the correct answer using the musical terms in this level. (4 points)

a. An_____is a song for solo voice within an opera or oratorio.

b. _____means moving by half steps.

c. _____means "light and fast" in French.

d. _____is a smooth glide from one note to another.

24. For the following questions, write "Granados, Fauré, or Copland" as your answer (9 points)

a. Granados died when he was _____ years old.

b. Copland's songs have been used as patriotic songs for which country?_____

c. Copland's famous piano teacher was the famous Nadia_____

d. _____ was a member of the Société Nationale de Musique.

e. This composer wrote music for films._____

f. Grandos founded a music Academy in_____.

g. This composer was given a tribute concert in his honor._____

h. This composer wrote the opera *The Tender Land.*_____

i. This composer performed at the White House for President_____

Final Score:_____/98
answer key begins on the next page

Level 7 Review Test: Answers

1. What minor key is this song in? ___c___ minor

2. Define the term "Misterioso." __mysterious__

3. What type of cadence is in the Bass clef in measures 3-4? __Half__

4. What type of cadence is in the Bass clef in measures 7-8? __Authentic__

5. How many times is this song sung? _____once

 __X__twice

6. What type of ornament is in the vocal line in measure 1? __Grace note__

7. Write the solfege syllables for the circled section in m.6.

or	Do	Te	Le	Te	Sol
	La	Sol	Fa	Sol	Mi

8. Write an ascending and descending chromatic scale beginning and ending on middle C. (2 points, one for ascending, one for descending)

9. Write the enharmonic note after the given note for each example. (4 points)

10. Add 3 bar lines and a double bar line to the following example. (4 points)

11. Choose the missing time signature, add it to the example, then write the beats underneath the notes. (5 points-one for the time signature, one for each correct measure)

1 & 2 & 3 1 e & a 2 3 & 1 2 3 e & a 1 & 2 3 &

12. Name, then draw the relative minor scale in its natural form below the given Major scale. Use whole notes, ascending only. (2 points)

f minor

13. Write the key signature, then draw an ascending natural minor scale in the requested keys. (4 points)

d minor

g♯ minor

14. Label the following ornaments with their correct name. (3 points)

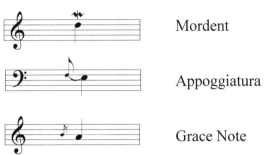

Mordent

Appoggiatura

Grace Note

15. Label the following chord progressions with the correct Roman numerals. Make sure to pay attention to the key signatures. In the Major example, chords are shown in inversions. (8 points)

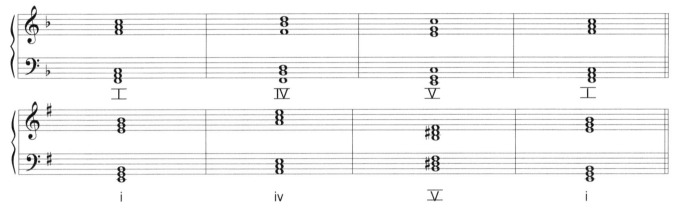

I IV V I

i iv V i

16. Draw the correct chords according to the Roman numerals given. You may need to add an accidental to the dominant chord in the minor key in order for the chords to be correct. You may use either root position or inversion chords. Pay attention to the key signatures. (8 points)

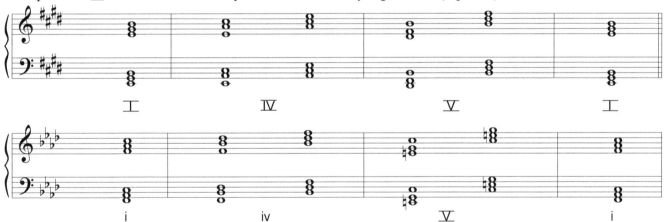

I IV V I

i iv V i

17. Match the cadences with their correct name. All examples are in a Major key and in Root Position (3 points)

 c Plagal

 a Authentic

 b Half

18. Write the beats under the following rhythmic example. (4 points)

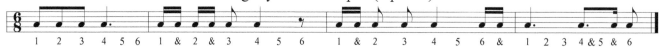

19. Write the note names and solfege under the notes in the following examples. Pay attention to the key signature. (8 points)

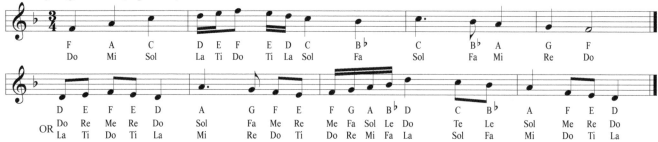

F	A	C	D	E	F	E	D	C	B♭	C	B♭	A	G	F
Do	Mi	Sol	La	Ti	Do	Ti	La	Sol	Fa	Sol	Fa	Mi	Re	Do

	D	E	F	E	D	A	G	F	E	F	G	A	B♭	D	C	B♭	A	F	E	D
OR Do	Do	Re	Me	Re	Do	Sol	Fa	Me	Re	Me	Fa	Sol	Le	Do	Te	Le	Sol	Me	Re	Do
La	La	Ti	Do	Ti	La	Mi	Re	Do	Ti	Do	Re	Mi	Fa	La	Sol	Fa	Mi	Do	Ti	La

20. Match the voice classifications below with their definitions. (11 points)

Coloratura Soprano j

Lyric Soprano e

Dramatic Soprano f

Mezzo Soprano c

Contralto (alto) b

Countertenor g

Lyric Tenor k

Dramatic Tenor h

Baritone a

Bass/Baritone i

Bass (Basso Profundo) d

21. Check the English word that contains the same sound as the given IPA symbol. (4 points)

ɲ -onion ɑ̃ -fond ɛ̃ -grand ʒ -beige

22. For the following questions, check the correct choice that best describes how the French word would be pronounced. The IPA spelling is provided for you, in parentheses, after the word. (4 points)

dans (dɑ̃)- don (with open n) je (ʒə)- juh (soft j) une (yn)- oon blanche (blɑ̃ʃ)- blah-n-shuh

23. Fill in the correct answer using the musical terms in this level. (5 points)

 a. aria

 b. chromatic

 c. léger

 d. portamento

24. For the following questions, write "Granados, Fauré, or Copland" as your answer (10 points)

 a. 49

 b. USA

 c. Boulanger

 d. Fauré

 e. Copland

 f. Barcelona, Spain

 g. Fauré

 h. Copland

 i. Wilson

REFERENCES

Grout, Donald. *A History of Western Music.* New York, NY: W.W. Norton & Company, Inc., 1996.

Moriarty, John. *Diction.* Boston, MA: E. C. Schirmer Music Company, 1975.

Music Teachers' Association of California. *Certificate of Merit Voice Syllabus.* San Francisco: Music Teachers' Association of California, 2011.

Piston, Walter. *Harmony, Fifth Edition.* New York, NY: W.W. Norton & Company, Inc., 1987.

Plantinga, Leon. *Romantic Music, A History of Musical Style in Nineteenth-Century Europe.* New York, NY: W.W. Norton & Company, Inc., 1984.

Randel, Don Michael. *The Harvard Biographical Dictionary of Music.* Cambridge, Massachusetts: The Belknap Press of Harvard University Press, 1996.

Randel, Don Michael. *Harvard Concise Dictionary of Music.* Cambridge, Massachusetts: The Belknap Press of Harvard University Press, 1978.

Rushton, Julian. *Classical Music, A Concise History from Gluck to Beethoven.* London, England: Thames and Hudson Ltd., 1986.

The New Grove Dictionary of Music and Musicians. http://www.oxfordmusiconline.com., 2011